A Treasury of Tom Thomson

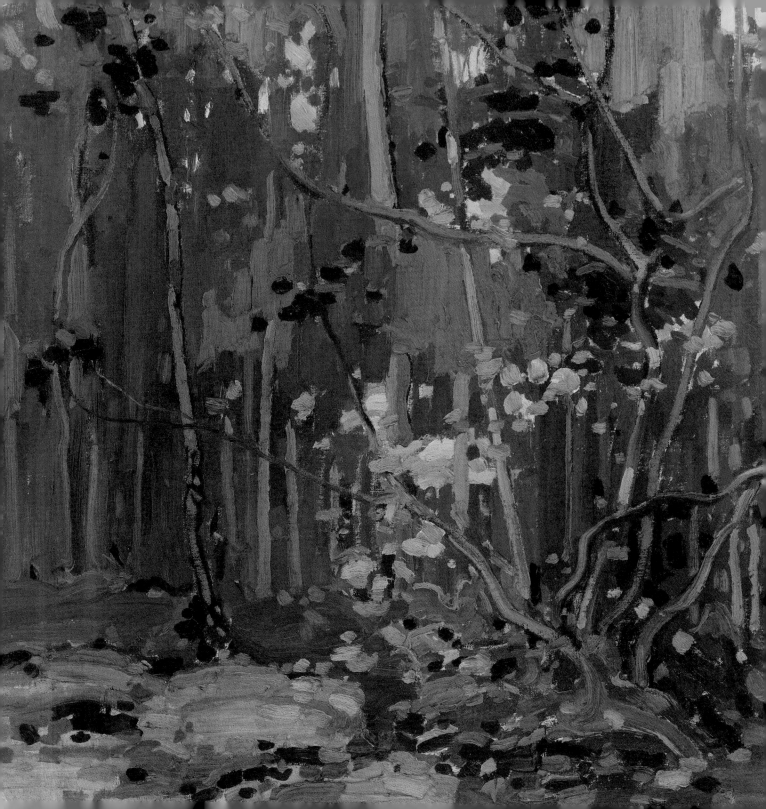

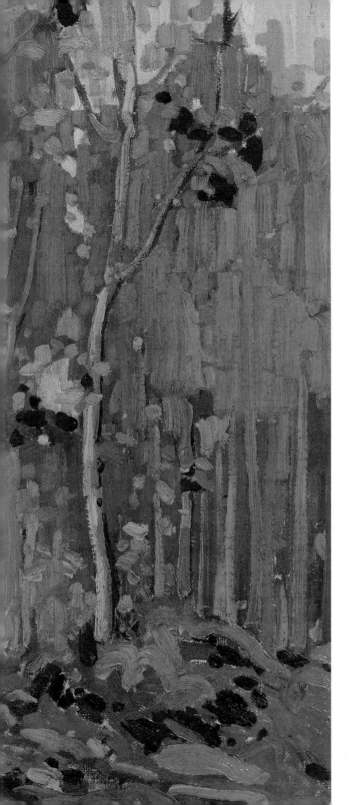

A Treasury of Tom Thomson

JOAN MURRAY

Douglas & McIntyre

D&M PUBLISHERS INC.

Vancouver / Toronto / Berkeley

Text Copyright © 2011 Joan Murray
Design Copyright © 2011 Counterpunch Inc.
First U.S. edition 2012

11 12 13 14 15 5 4 3 2 1

Douglas & McIntyre
An imprint of D&M Publishers Inc.
2323 Quebec Street, Suite 201
Vancouver BC Canada V5T 4S7
www.douglas-mcintyre.com

Cataloguing data available from
Library and Archives Canada
ISBN 978-1-55365-886-3 (pbk.)

Produced by Counterpunch Inc.
Editing by Rosemary Shipton
Copy editing by Ruth Gaskill
Index by Dan Liebman
Cover and interior design by Counterpunch Inc./Peter Ross
Typeset in Cartier Book, designed by Rod McDonald,
 based on Cartier, originally designed by Carl Dair;
 and Figgins Sans, designed by Nick Shinn

Printed and bound in China by C&C Offset Printing Co., Ltd.
Text printed on acid-free paper
Distributed in the U.S. by Publishers Group West

We gratefully acknowledge the financial support of the Canada Council for the Arts, the British Columbia Arts Council, the Province of British Columbia through the Book Publishing Tax Credit, and the Government of Canada through the Canada Book Fund for our publishing activities.

PHOTO CREDITS

Agnes Etherington Art Centre: 29 (right), 95
Art Gallery of Hamilton: 67
Art Gallery of Ontario © 2010 AGO: 45, 51, 77, 81, 109, 119, 129, 145
Colourgenics Inc.: 30–31 (detail), 89, 100, 101, 113
Michael Cullen: ii–iii (detail), viii–1 (detail), 19 (detail), 22–23 (detail), 27 (detail), 39, 49, 57, 63, 65, 71, 73, 79, 83, 85, 93, 97, 103, 105, 107, 117, 121, 123, 127, 133, 135, 139, 141
McMichael Canadian Art Collection: 43, 47, 53, 55, 87, 99, 111, 137, 143
Museum London: 29 (left), 115
Kenji Nagai: 14 (detail), 28 (left, middle), 41, 75
National Gallery of Canada © NGC: 8, 9 (detail), 28 (right), 35, 37, 59, 69, 82, 90, 91, 125, 131
Thomas Moore Photography: 33
Tom Thomson Art Gallery: 61

Paintings on pages 57, 73, 79, 83, 97, 103, 105, 117, 121, 123, 127, 135, and 139 are on view at the Art Gallery of Ontario, Toronto, in the Thomson Collection of Canadian Art.

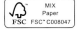

Preceding spread: detail, *Maple Saplings, October* (page 127)

Contents

Acknowledgements

For four decades and more, I have been researching and writing about Tom Thomson and organizing exhibitions of his oeuvre. During that time I have been privileged to hold almost all his paintings and sketches in my hands and to observe the notations on the backs of many of them. These inscriptions have their own fascinating story to tell – how Thomson's close artist friends and later major collectors chose these works as his best – and I decided to write another book about Thomson to share these special paintings with readers. I am pleased that Douglas & McIntyre, my publisher, found virtue in this idea.

Many individuals love the work of Tom Thomson and have supported my endeavours with regard to this book. I am grateful to them for their enthusiasm. I am also indebted for access to works favoured by both the late Ken Thomson and David Thomson. For their support, I want to thank Rod Green of Masters Gallery Ltd., Calgary; David and Robert Heffel of Heffel Fine Art Auction House, Vancouver; Geoff Joyner of Joyner Waddington's Canadian Fine Art, Toronto; Merete and Torben V. Kristiansen of the Art Emporium, Vancouver; Peter Ohler of Peter Ohler Fine Arts, Vancouver; Michael J. Tims, Calgary; and, in particular, A.K. Prakash of A.K. Prakash and Associates, Toronto.

For the exact wording of the inscriptions Lawren Harris, J.E.H. MacDonald, A.Y. Jackson, and Dr. J.M. MacCallum wrote on the verso of Thomson's canvases and sketches, I relied on the catalogue raisonné of Thomson's works I prepared over four decades. Rob Cowley of Joyner Waddington's, Toronto, assisted me in recording the inscriptions on the back of *Winter Morning* (page 41) and shared with me the text he prepared in 2009 for the sales catalogue of his auction house. And, at the National Gallery of Canada, Charles C. Hill and Julie Levac supplied answers for queries I sent to them.

Linda Gustafson and Peter Ross of Counterpunch expertly helped me with the brilliant design of the book and its enriched contents. Along with the remarkable editor Rosemary Shipton, they all helped give the book its present shape. Ruth Gaskill followed through with a meticulous copy edit, and Dan Liebman prepared the index. I am grateful to this team of dedicated individuals, the "Tiny Tom" group, who took such a special interest in the project. They have my heartfelt thanks. Without them and Ash Prakash, this book would not have happened.

Joan Murray
April 2011

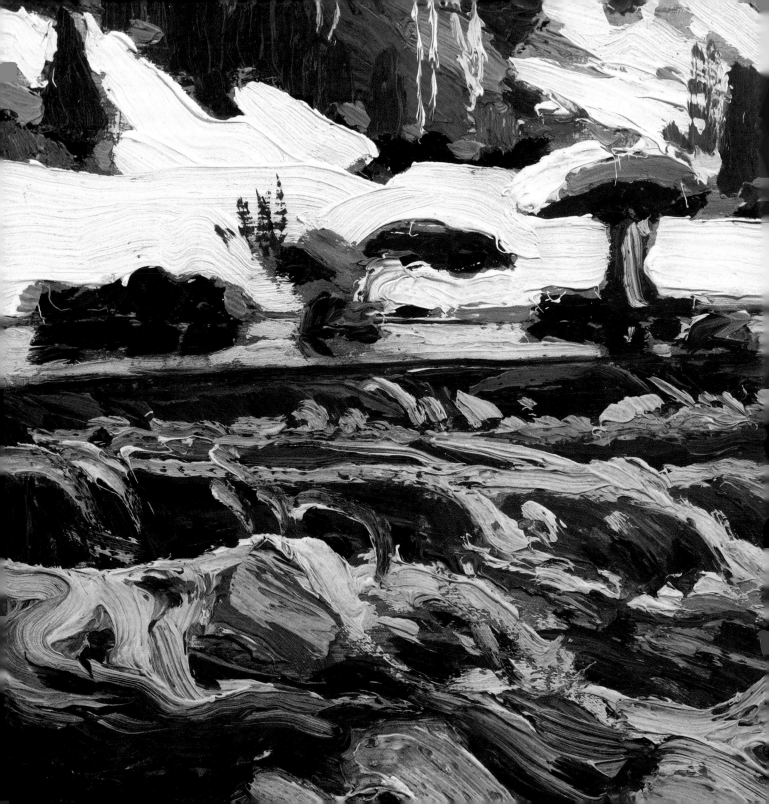

CREATING A LEGACY

Detail, *The Rapids* (page 141)

DURING HIS LIFE, Tom Thomson was little known as an artist beyond a small circle of friends in Toronto. Yet a year after his death in 1917, many of his best paintings had been purchased by the National Gallery of Canada in Ottawa or by some of the major private art collectors in the country. He was already well on his way to becoming a great Canadian artist – one who captured the public imagination and inspired Canadians to see their rugged northern landscape through his eyes. The story of how this transformation happened is one of the most moving in the history of Canadian art.

Thomson was born in 1877 and grew up on Rose Hill farm near Leith, Ontario, not far from Owen Sound, a busy port and manufacturing town on Georgian Bay in Lake Huron. His parents were avid readers of poetry and prose, and most of his nine siblings were musical and artistic. Thomson himself played the mandolin and liked to sing. For several years he was absent from school because of an illness, and he spent that time rambling through the countryside and fishing. After he recovered, he worked on the farm and even apprenticed as a machinist in town (the job did not last). He inherited $2,000 from his grandfather, a large sum in 1898, and it helped to support his carefree lifestyle for a few years as he tried to figure out what he really wanted to do. In his early twenties, he enrolled in a business college to study commercial art – first in Chatham, Ontario, and then at the Acme Business College, run by his brother George and a friend in Seattle, Washington. There he learned fine penmanship and commercial design. By this time his inheritance was already exhausted, and he worked for a few years in Seattle at engraving firms, specializing in advertising.

In 1905 Thomson settled in Toronto, an expanding and bustling city with more than a quarter of a million people, and made it his home base for the rest of his life. He was a handsome young man, with dreamy eyes and a shock of dark hair that fell over his forehead, and quite the dandy – he particularly liked bow ties and broad-brimmed hats. He worked first at Legg Brothers and other firms and then as an independent designer. In 1909 he got a job at Grip Limited, Engravers. The work he did there honed his design skills, and his colleagues in the art department changed his life.

The railway and shipping companies were among the biggest clients for engraving firms at the time. They ordered posters, brochures, and advertising materials to promote immigration, western settlement, travel, hotels, and resorts. To make Grip competitive in this lucrative market, Albert H. Robson, the art director, wanted to discover a distinctive imagery that would capture the spirit of Canada. He encouraged the senior artist, J.E.H. MacDonald, and the younger men on staff to go out on weekends and paint landscapes around Toronto. They made contact with members of the Toronto Art League and the Mahlstick Club and went on sketching trips to find picturesque scenes that were new and "Canadian."

In 1911 Thomson travelled to Lake Scugog to paint, along with Ben Jackson, a friend from Grip. The next year, in May, they went to Algonquin Park, a provincial park that city dwellers regarded as the north country – romantic, mysterious, vast, and wild. There Thomson made several quick colour sketches of the terrain. Over that summer he and William Broadhead, another friend from Grip, explored the area northwest of Sudbury by canoe. They sketched in oil and took many pictures with a camera. These trips changed the direction of Thomson's life; in the fall, the budding artist invested in his first painting kit.

When Thomson showed his colleagues at Grip the small panels he had painted, they encouraged him to develop his art. The sketches were dark, even muddy in colour, but truthful in feeling. Thomson respected these men, most of whom, unlike him, had

received good training as artists. The group included two recent arrivals from England, Arthur Lismer and F.H. Varley, and, through an exhibition of MacDonald's work at the Arts and Letters Club, Thomson met other talented artists such as Lawren Harris. Praise also came from a new acquaintance he made that year – Dr. James MacCallum, an eye doctor who owned a cottage on Georgian Bay and who introduced him later to A.Y. Jackson, a painter from Montreal.

These men were united in a dream – to create a distinctive Canadian art movement that would capture in paint the true spirit of the north country. They were rebels, and they wanted to break away from the subjects and styles of the past and paint directly from unspoiled nature. In early 1913 MacDonald and Harris travelled to Buffalo to see an exhibition of contemporary Scandinavian paintings at the Albright Art Gallery. They were excited by what they saw there – paintings of a rugged northern landscape, with powerful forms and bold colours, the snow piled high like sculptures or tracing a glistening, delicately tinted tapestry over the trees. It was exactly the kind of art they wanted to do in Canada, and they brought back a catalogue of the exhibition to show to their friends in Toronto. Harris and MacCallum, the only men with money in the group, decided to build the Studio Building in the Rosedale ravine near Yonge Street to provide inexpensive space for the artists to rent. Already this group of men was sometimes being called the "Algonquin Park School."

Events began to move quickly for Thomson. In the spring of 1913 he took a leave of absence from his job and travelled north. He planned to spend the next few months there, working when he could as a fire ranger or a fishing guide, though his main goal was to absorb the landscape through the ever-changing weather patterns and seasons and record his impressions in quick small sketches. Late in the autumn he returned to Toronto for the winter and developed some of these works into more finished large canvases. The Studio Building opened in January 1914, and he and Jackson shared one of the light-filled rooms. Jackson taught him about colour, new art movements in Europe,

and how to prepare his canvases like a professional. Thomson built himself a duplicate of Jackson's travelling sketch box, which acted as a palette and held three 8½-by-10½-inch panels.

Thomson's enthusiasm for his new simple way of life in the park was infectious. His artist friends saw him as their guide to the north country, not only for his practical skills in cooking, camping, and canoeing but also for his ability to capture in paint the essence of that raw landscape. Dr. MacCallum offered to be his patron for the next year so that he could resign from his job in the city and devote himself full-time to his art.

From this time on, Algonquin Park, in all its diversity, became the main theme of his work. The park was easily accessible by rail and boasted four luxury summer resorts. Thomson avoided the holidaymakers, preferring to stay at the modest Mowat Lodge, a converted workers' barracks near Canoe Lake, or in warmer weather to camp outdoors. The lumber companies were at work in the area, building roads and dams, hauling out the logs, and occasionally burning over the land. Thomson was primarily interested in the park as a wilderness of lakes, rivers, wildflowers and bushes, and forests with a variety of trees – an area that changed completely with the seasons, from the breakup of the ice in early spring to the lush growth of summer, the vivid colours of autumn, and the heavy snows of winter. Its mood altered daily with the weather – sun, cloud, rain, hot or cold, and the occasional spectacular aurora borealis. Thomson wanted to record it all.

There was great camaraderie among the group of artist friends that year, 1914. In May Lismer visited Thomson for three weeks, and, while canoeing, portaging, and camping by various lakes, they scouted for scenes to sketch and talked about art. Then, in October, Jackson and the Lismer and Varley families all came to stay, and again they sketched directly from nature and discussed art. Jackson was familiar with Impressionism and Pointillism from his studies in France, and Lismer knew a lot about John Constable, the master of British landscape painting, famous for his clouds and skies.

That autumn marked a major turning point in Thomson's career. With encouragement from his friends, he realized he could control the way he painted. He did not have to make a literal representation of the scene before him: he could transpose or eliminate or contract the elements to create a strong composition – he was free to design nature. The idea liberated him and gave his work new power. His sketches became bold and filled with brilliant, pure colour. He experimented with different techniques for applying paint with his brush, sometimes in a terse network of strokes and dots, other times in broad patches of contrasting tones. All of them recorded nature in graceful compositions of rhythmic pattern and luxuriant colour.

Over the next three years, Thomson repeated this routine of arriving in Algonquin Park at spring breakup, painting and occasionally working through the warmer months, and returning to Toronto in the late fall. Dr. MacCallum visited sometimes and accompanied Thomson on camping and fishing trips, and Harris also came to stay. (Jackson had already volunteered for service in the First World War, and Harris followed.) Every time the artist friends got together they continued to inspire and learn from each other.

Thomson made over four hundred sketches and, over the winters in the Studio Building or in his little shack just behind, painted about thirty-five canvases, eight of them developed directly from his sketches. These larger pieces were skilfully composed and painted, but they lacked the energy, spontaneity, and immediacy of the original sketches. To gain recognition, Thomson hoped to show these paintings at the juried exhibitions, particularly those organized annually by the Ontario Society of Artists and the Royal Canadian Academy of Arts. During this short three-year span he actually painted even more sketches, but he destroyed many he did not like. Generous to a fault, he gave away many to friends and people he met who admired them.

~

In July 1917 Tom Thomson died at Canoe Lake, mysteriously. His close artist friends, once they had worked through their initial shock and sorrow, devised a constructive plan. Thomson had been one of them, a guiding spirit in their Algonquin Park School; they would not allow his budding reputation to die with him. Rather, they would try to enhance his stature as an artist and give him a new profile – as the genius in their midst.

Sometime in the spring of 1918 Harris and MacDonald agreed to act as the unofficial trustees of Thomson's art. Years before, Thomson had asked Harris to manage his finances and even gave him his bank book. Now that Thomson was dead, Harris felt honour-bound to act as Thomson's representative in financial matters. But the short-term goal of settling the estate was not enough. Harris and MacDonald decided that, in addition to finding buyers for the paintings and sketches stacked up in the Studio Building in Toronto where Thomson had left them, they would do their best to position him for all time as one of Canada's greatest painters. It was an ambitious plan.

Over the following months these two busy men put aside their own artistic endeavours and discussed how best to enhance Thomson's reputation in Canadian art. They knew they had first to place his work in prominent collections, both private and public. Thomson had sold only a few works during his lifetime, but now, if they could extend these sales to discriminating and influential purchasers, his paintings would be treasured and his position assured.[1]

～

Already in the fall of 1917 MacDonald had begun to consider what he should do about Thomson's work. He felt a special responsibility to act as a trustee of Thomson's legacy simply because he had been the artist's boss at Grip. As a first step, he ordered one hundred frames for Thomson's small sketches and framed two canvases that Thomson had left in the Studio Building.[2] Later, because most of the works were unsigned, he designed

and applied a Tom Thomson estate stamp to all the works there that lacked a signature, verifying them as authentic. The stamp is in the shape of an artist's palette, with "TT" and the year "1917" on it. There are two identical versions, each about the size of a fingernail – one a metal die and the other in rubber.

When Harris returned from military service the following spring, he and MacDonald gathered all the Thomson pieces on hand in the Studio Building. They counted thirty-five large canvases and around four hundred small sketches.

MacDonald and Harris decided that their first task was to evaluate Thomson's works and then to promote the best of them. They quickly made a selection from the canvases, but the large groups of sketches proved a far greater challenge. Harris wrote "first class" on the backs of those he considered outstanding, as though he were a teacher marking a school exercise. He and MacDonald classified another group of sketches as "not for sale" or "reserved," for purchase by themselves, by friends in the art community, or by public institutions. They selected sixty works in total, all of which Thomson had painted in the period from the fall of 1914 to the early spring of 1917. In doing so, they marked their preferences permanently on the works themselves, thereby creating a unique way for viewers to distinguish an excellent work by Thomson from a mediocre one – at least in their opinion.

Their idea caught on, and they were joined by some of Thomson's other friends, such as his mentor Jackson and his benefactor Dr. MacCallum. The museum community also proved receptive: Eric Brown, the director of the National Gallery of Canada, for example, purchased twenty-five oil sketches by Thomson in 1918 and two large paintings, *The Jack Pine* and *Autumn's Garland*, and made sure that pieces such as *Spring Ice*, which the gallery had purchased in 1916, were included in exhibitions that travelled to cities across Canada and abroad (pages 131, 82, and 91).

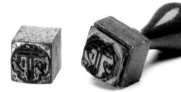

The estate stamp designed by J.E.H. MacDonald. National Gallery of Canada, Ottawa, bequest of Dr. J.M. MacCallum, 1944

Detail, *Spring Ice* (page 91)

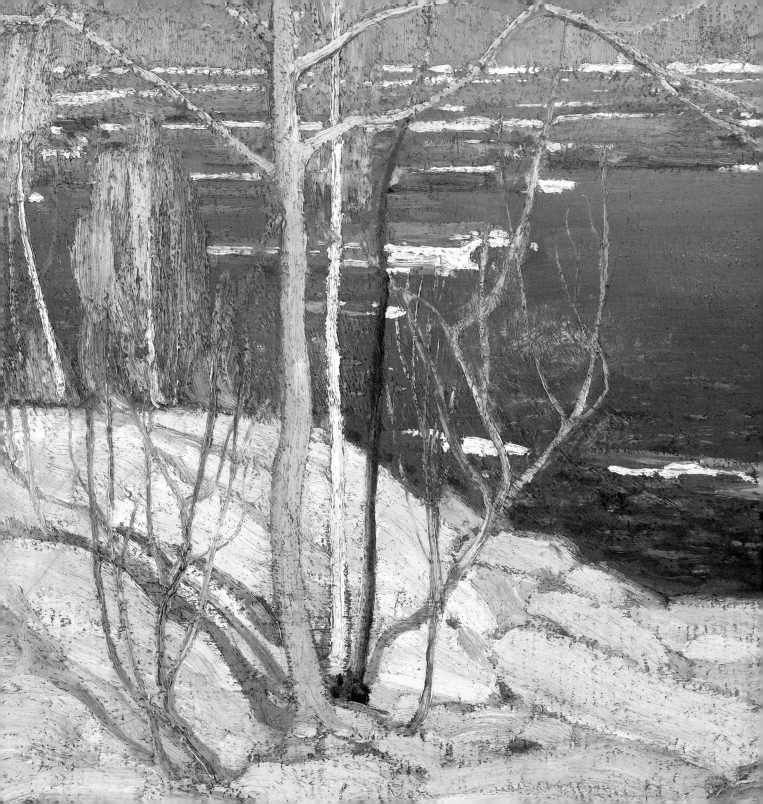

In this way, the Tom Thomson we know today from galleries and books began to take form. The friends who came together as the Group of Seven in 1920, three years after his death, portrayed him in their writing and in conversation as a figure of legend, an outdoorsman, and a natural genius. They acknowledged the critical influence he had made on their own work through his bold treatment of oil paint, his abbreviated yet delicate brushwork, and his evocative stretches of brilliantly coloured canvas. Ultimately they recognized that, in many ways, they would never be able to paint as he did. He began as the student among them, they said, but he rapidly became the master.

~

It is fair to ask why Harris and MacDonald took on this mammoth task. Initially Harris probably had his own private reasons. His brother, Howard, had been killed in France while inspecting a German trench. That tragic news, coming a few months after Thomson's death, caused him to suffer a nervous breakdown. He resigned his appointment as an officer in the Canadian Infantry, left Camp Borden (a large military training establishment west of Barrie, Ontario), where he had been working as a gunnery instructor, and came home to Toronto. He needed distraction from his grief, a practical activity that did not require any output of creative energy from him. And, with MacDonald's encouragement, he probably felt that his grief could be mitigated by helping to settle Thomson's estate. Around the same time, Harris organized a few trips to Algoma and other northern regions. Both activities helped to clear his mind – and, as it happened, they also gave him new breadth as an artist.

Although Thomson's special friends among the future Group of Seven – MacDonald, Harris, Lismer, Varley, and Jackson – had all trained as artists in Canada, England, Belgium, Germany, or France, Thomson, in the few years they knew him, had become their interpreter of the north country they wished to paint. They believed his vision of

this landscape was "truer" than their own.[3] MacDonald and Harris described Thomson in remarkably similar ways, even using the word "genius." In an article he wrote in 1917, MacDonald commented on Thomson's "concentration of purpose, and his natural genius and knowledge, and sympathy with his subject."[4] And in a 1944 National Film Board of Canada documentary about Thomson, *West Wind*, Harris said: "Tom Thomson had many of the characteristics of genius as a painter ... a concentrated directness that went right to the heart of whatever he was painting and an easy and deft yet inspired skill in applying paint which drew from the colour its maximum vitality. This last," he continued, "is a sure sign of the born painter." By immersing himself in Thomson's work that spring of 1918, Harris had learned a lot about how best to portray the Canadian landscape in all its variety and how to become the distinctive nationalist landscape painter he wanted to be.

Later, in *The Story of the Group of Seven*, published in 1964, Harris explained in detail the debt he and his fellow artists owed to Thomson. He knew the north country "as none of us did," he wrote, "and he made us partners in his devotion to it." At the time, there were no exhibitions of modern painting in Canada. "No exhibitions came from Europe ... and nothing at all came from the United States. Thus, in everything to do with art, we were entirely dependent on ourselves. We had to generate within ourselves everything which made for the development of our work. So we continuously derived inspiration and encouragement from one another."[5]

The Thomson sketches that Harris marked as "first class" were those that offered him inspiration – and encouragement. As such, they form part of the story of his own development as an artist. In 1950, when Harris created an abstract canvas that suggested trees, lakes, and campfire evenings, he recalled, "When I laid in the painting, it suddenly struck me that it could express Tom Thomson, and thereafter it was Tom I had in mind – his remoteness, his genius, his reticence."[6] He titled the work *In Memoriam to a Canadian Artist*.[7] Obviously Harris long had Thomson on his mind.

The reason Harris continued to think about Thomson for so many years and, in 1918, set aside his own work to become involved with his estate is tied to this word "genius." As Harris began to help MacDonald select Thomson's best works, he may have looked at his own paintings – done near Lake Simcoe, about one hundred kilometres north of Toronto – and wondered where the genius was in them. Certainly they could be considered exciting in the way they radically updated the Canadian landscape tradition, but where was the feeling for new potential that was such a salient characteristic of Thomson's work? And how had Thomson achieved that particular quality anyway?

Crucial for Harris in Thomson's works were not only their compositional and formal qualities and the landscape they portrayed but also Thomson's gift for handling colour, making it reveal its greatest vitality. That must be the key to Thomson's secret, Harris thought – Thomson's way of combining different colours within one work and the way he set one colour against another, so that they came together seamlessly to achieve a gripping result.

Much of the pleasure in looking at Thomson's work derives from the exquisitely sure touch he applied in his sketches to what he had seen, along with a loving attention to brushwork. Still, as Harris, MacDonald, Jackson, and all his other friends knew, there was something more than a highly developed talent here. They tried to explain what made Thomson so special, but they could not quite put their finger on it. Perhaps that mysterious quality alone explains his genius. In the years that followed, these friends spoke of Thomson with affection, tinged with regret. "He should have been with us," they said. "He was a part of us" – and he remained in their thoughts.

∼

The sketches Harris and MacDonald set aside suited their personal ideals. In selecting their favourites among Thomson's works, the two men sometimes differed. Harris liked

sketches that are exciting in terms of composition, design, and that special handling of colour that intrigued him. MacDonald, in contrast, chose sketches with rich, even gorgeous, colour. Harris wrote "first class" on the compositionally packed *Wildflowers*, for instance, but not on *Marguerites, Wood Lilies and Vetch* (pages 53 and 51). It was MacDonald who marked this beautiful sketch "not for sale." Harris marked *Tamarack Swamp* as "first class." It has a grand design yet great simplicity of composition. The touches of red in the foreground and the powerful contours of the clouds and sky ignite the otherwise sombre scene (page 75). He also selected *Sand Hill*, where Thomson achieved a similar harmony by playing the shapes of the land and the trees against each other (page 79).

Whatever their choices, both Harris and MacDonald would have been sympathetic to the other's selections. They were not infallible, of course, and later collectors have sometimes disputed their decisions. But they were also not afraid to follow their instincts and commit themselves to the pieces they liked.

In the flower studies Harris or MacDonald selected, the contrasting shapes of strongly modelled and briefly indicated plants fill the surface of the sketches with excitement (pages 51–55). In other works, they responded to the sensitive way Thomson observed colour – in *Wild Cherries, Spring*, for example, he exquisitely depicted the various colours of the dawn (page 43).

In their choice of works, MacDonald and Harris responded not only to Thomson's strengths – his bold colour; his brilliance at isolating telling images in nature and expressing them in well-designed compositions; and his dense field of sometimes emphatic, sometimes delicate brushwork – but also to something new they sensed in his work. Harris had studied art in Berlin, and he and MacDonald had travelled together to the exhibition of Scandinavian Post-Impressionist art in Buffalo. The uninhibited approach to the northern wilderness they observed there stimulated them and clarified their ideas for their own work in Canada. MacDonald even annotated the catalogue he brought back with him.[8]

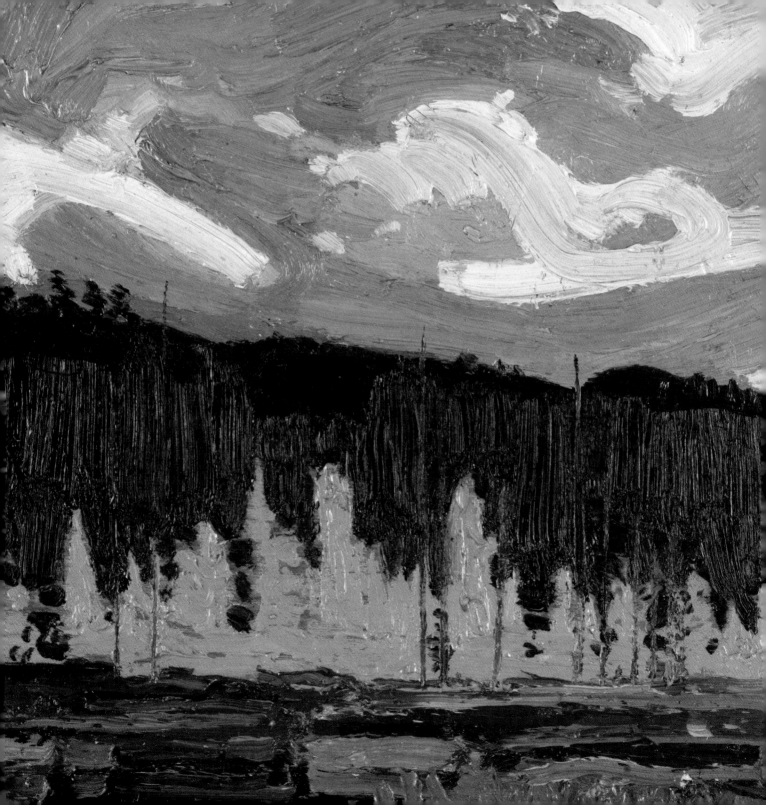

Now, as they reviewed Thomson's oeuvre, they recognized that same freedom in his later works. Sketches such as *The Rapids* displayed the dazzlingly intense colour of this new art, a bolder sense of form and composition, and an overall expressive quality (page 141). Jackson had remarked on Thomson's "cubistical tendencies," and Varley wrote that "Tom is developing into a new cubist" – the epitome of avant-garde art to these painters.[9] In some sketches, Thomson seemed on the cusp of abstract art – a style that Canadian painters ignored for another three decades. In this sense, the selection MacDonald and Harris made constitutes a fascinating time capsule not only of their personal taste but also of a particular historical moment.

It is also interesting to note what Harris and MacDonald omitted in their selection. They focused attention on paintings they valued, especially Thomson's record of the rugged landscape of Algonquin Park. But Thomson had a totality of vision that included a few efforts to record the urban environment and the industrial age through his paintings of the lumber trade (page 101). These works may not have seemed as important to his friends because they did not embody their ideal as nationalists and their growing devotion to the north country as the most suitable location for Canada's art.

The feeling that Thomson offered an important insight into the landscape and the variety of weather conditions in the North may account for the way Harris and MacDonald originally sorted his sketches in the Studio Building – not by date as they assessed it but by subject and season. MacDonald's son Thoreau recalled that the works were stacked in shelves marked "Snow, Sunsets, Spring, Summer, Fall, and so on."[10] In a way, they followed Thomson in this organization because, although he had not given a title to most of his sketches, the few he did title followed the seasons or some category of nature.

Nor had Thomson dated most of his works. Art historians rely to some extent on the various panels he used for clues to probable dates. For his early sketches he used Birchmore boards, a paperboard faced with canvas, which he purchased. In the spring of 1914 he switched to birch panels, and in the fall to a grey composite wood-pulp board.

Detail, *Tamarack Swamp* (page 75)

The next year he used some wood panels but mostly the composite boards, and in 1916 he painted primarily on wood panels. Then, in 1917, he again used wood panels but also small boards he had salvaged from crates. He was certainly thrifty, though he liked to use good-quality paints, including the expensive ultramarine blue.

In their notations on the back of their selected paintings, Harris and MacDonald made a considerable effort to be scrupulously accurate in what they wrote. Harris seems to have changed his mind about some of the works he had marked initially, and he was likely the person who crossed out the words "first class" on the verso of several sketches, such as the excitingly bold *Blueberry Bushes, October* (page 121). And, when a potential collector changed his mind, Harris crossed out "reserved ... [for?] Laidlaw" on the back of another work, *Ragged Pine* (location unknown).

MacDonald, like Harris, sometimes recorded specific memories on the back of a work. On one sketch of the Petawawa Gorges in Algonquin Park, for instance, he wrote that Thomson regarded it as his best work and wanted to use it as the basis for a large painting (page 109). Curiously, this gritty sketch looks ordinary beside so many other more beautiful pieces. In all likelihood Thomson was intrigued by the way he had captured the effect of light and volumetric design in this quick sketch, and he hoped to build on its interesting composition during the winter months in the Studio Building with fine brushwork and a more sophisticated sense of colour.

∼

It was important to Harris and the other members of the Group of Seven to have a few works by Thomson in their own personal collections. These works became object lessons on the qualities they admired in his paintings and sought to emulate. After Thomson's death, Jackson chose the sketch *The Rapids* for himself because he thought he could never paint a river quite that way and hoped, by living with it, to absorb something of

Thomson's knowledge and technique (page 141).[11] MacDonald owned Thomson's dazzling sketch *Marguerites, Wood Lilies and Vetch* (page 51). He was fascinated by the colour, textures, and shapes of flowers and, two years earlier, had exhibited his own controversial flower painting, *The Tangled Garden* (National Gallery of Canada).[12]

Lawren Harris had acquired at least one work during Thomson's lifetime: the canvas *Burnt Land*, which, though small, is powerful in its simplicity and composition. He owned the sketch *A Rapid*, perhaps also obtained before Thomson's death, in which the water of the small stream appears to burst from beneath a dark curtain of foliage and fallen trees (pages 37 and 81). In 1918 he selected two more sketches that interested him in some special way: *Black Spruce and Maple*, where the colour of the fall trees is enriched simply by their setting against a screen of dark spruce, and *Autumn Birches*, which has an exciting coloration and feeling of depth (pages 77 and 119).

~

In their involvement with Thomson's estate, Harris and MacDonald acted not so much as purchasers but as expert advisers in their efforts to situate Thomson in Canadian art and get his best works into Canadian collections. To accomplish this goal they had to be specific and intelligent in their selections – to guide others who might not otherwise understand what was important about Thomson.

Some of the friends or acquaintances with whom they placed works were members of Canada's social elite, many of them artists or writers themselves. Harris, for instance, advised Walter Laidlaw and his brother Robert Laidlaw, who were prominent financiers and industrialists. With his help, they bought twenty sketches from the estate. Fred Housser, who met Harris first at St. Andrew's College, a private school in Toronto, bought *Wild Geese: Sketch for "Chill November"* (page 115), and Barker Fairley, a writer and professor of German at the University of Toronto, chose *Open Water, Joe Creek* (page 135). Both men became deeply

involved with the Group of Seven. Housser, an art critic and financial editor for the *Toronto Daily Star*, wrote the first major book on the subject, *A Canadian Art Movement* (1926). Fairley was an enthusiastic supporter of the group's basic ideal of creating a nationalist art movement. Jackson, for his part, advised Colonel Sam McLaughlin, a businessman and philanthropist, and told him to buy Thomson's sketch *Smoke Lake* (location unknown).

Dr. MacCallum already owned a number of works. Thomson had given him several pieces during his lifetime, and MacCallum had bought others. After Thomson's death he purchased the largest collection of Thomson's work in the country. In making his selection, he was influenced more by his love of northern Ontario than by any painting's aesthetic qualities, though merit mattered to him too. Given this perspective, his choices coincided only occasionally with those of Harris and MacDonald. The works he selected, such as *Lightning, Canoe Lake*, were important archival records of the North, he believed, as well as being beautiful (page 59). He kept most of his collection together, and, when he died in 1943, he bequeathed eighty-four Thomson paintings to the National Gallery of Canada.

Like Harris and MacDonald, MacCallum wrote on the backs of Thomson's sketches. His comments were discursive rather than evaluative, however, relating memories of camping trips he had enjoyed with Thomson and, based on his personal knowledge, attempting to title and date the sketches. The enthusiastic MacCallum would surely have been the person who influenced several medical doctors and many professors at the University of Toronto to purchase Thomson's work. He held a chair in ophthalmology at the university from 1909 to 1929 and continued practising at the Toronto General Hospital long after he retired from academia. Given these connections, it is no surprise that Dr. Duncan Graham, a brilliant medical reformer and educator at both the university and the hospital, owned Thomson's beautiful *Sun in the Bush* (page 103).

In public collections, the most important person by far to support Thomson's work in 1918 was Eric Brown, the director of the National Gallery of Canada. He had a specific vision of Thomson's art: for him the aesthetic value came first and the landscape subject,

Detail, *Sun in the Bush* (page 103)

though interesting, second. Brown came from Nottingham, England, where his brother Arnesby Brown was a well-known landscape painter. Brown moved to Ottawa in 1910 to take up his appointment as curator and two years later became the first director of the gallery, which had just been moved into the newly constructed Victoria Memorial Museum. He had wide interests in art and believed that a national gallery should represent the best of contemporary art as well as masterpieces from the past.[13] He also believed it was his duty to support living artists, especially those viewed as leaders among their peers.

In 1914 Brown began to purchase works by the Algonquin Park School, including paintings by Thomson and Lismer. The following year he and his wife, Maud, travelled to Algonquin Park so that they might better understand the Canadian landscape favoured by this group of artists. He saw Thomson and the entire Algonquin Park School as a valuable national asset. "There is no surer sign of the spiritual growth of nations than the condition of their art," he wrote. "There is developing in Canada a school of decorative landscape painting entirely original and indigenous and quite unparalleled on this continent."[14] He hoped that, through his strong support for the modern movement in Canada, the nation would take its rightful place in the art of the day. Canada, he said, "had in its midst a fine school of landscape artists equal to any."[15] Brown was a good friend and a uniquely positioned supporter, and he certainly established Thomson's reputation in Canadian art as much in his own way as did Harris, MacDonald, Jackson, and MacCallum in theirs.

Although MacDonald felt that *The West Wind* was "faulty and inconsistent,"[16] it entered the collection of the Art Gallery of Toronto (or Art Gallery of Ontario, as it later became) through the good offices of Jackson (page 129). The city where Thomson had lived and worked should have one of his large canvases in its collection, Jackson argued, and with the help of MacCallum and Dr. Harold Tovell, a member of the Exhibition Committee of the Art Gallery of Toronto, he persuaded the Canadian Club to present it to the gallery in 1926. The next year, after Harris donated the three Thomson sketches he owned to the gallery, it began to collect works by Thomson with some enthusiasm.[17]

Unfortunately, Harris, MacDonald, and the other friends who helped to sell Thomson's works after his death were not good archivists, and, as "helpers," they were modest. They kept no records of which public gallery or private collector bought which work. We know about the gallery purchases from their own records, and we have learned about some of the private purchases from letters that were saved or from later records of donations or sales at auction. But the record is incomplete. George Thomson went to Algonquin Park after his brother's death and returned with Thomson's few personal belongings and about thirty-five sketches he had made over the spring and early summer. Thomson had told the park ranger Mark Robinson that he had painted sixty-two sketches in total that season, recording the changing landscape in the park day by day, but he scraped off those he did not like, reused the panels, and destroyed others.[18]

These sketches were distributed among family members, though Harris did see some of them and, in his customary way, marked a few as first class. The works that remained unsold in the Studio Building also seem to have gone to the family after an interval, first into the care of the eldest Thomson sister, Elizabeth Harkness, and, after her death, to a younger sister, Margaret Tweedale. The family kept the sketches or sold them as opportunities arose, some to the Laidlaw brothers; later, Margaret donated others to the McMichael Canadian Art Collection.

~

Among the more recent collectors of Tom Thomson's paintings, some could almost be called "curators," because of their care and attention to his work. Two patrons in particular are outstanding: Robert McMichael and Ken Thomson, Lord Thomson of Fleet (no relation to the artist's family). Both began their collections in the 1950s.

In his autobiography, *One Man's Obsession*, Robert McMichael wrote that, from the moment he and his wife, Signe, placed their first Lawren Harris painting, *Montreal River*,

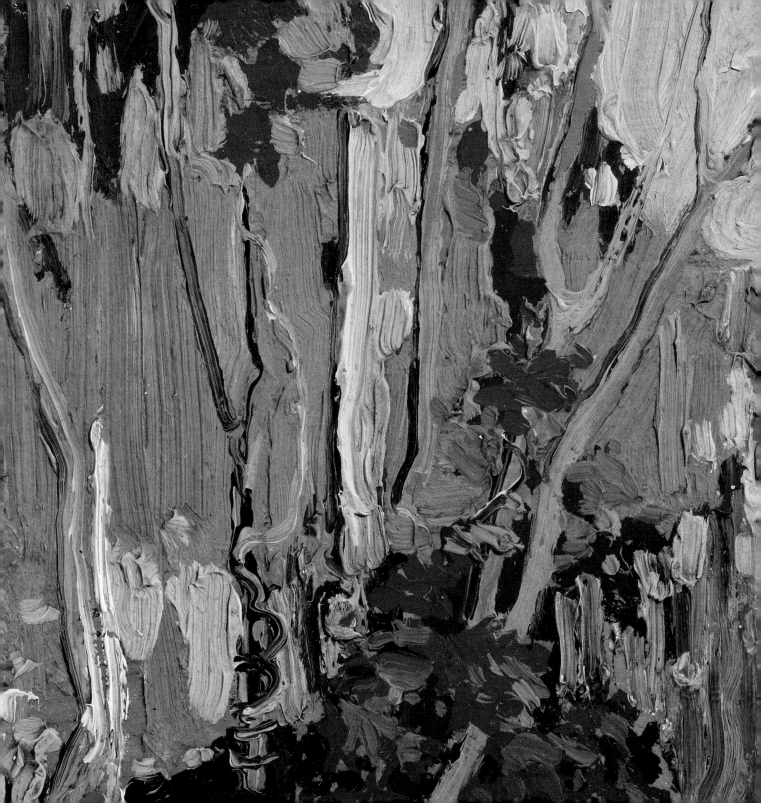

and their first Tom Thomson sketch, *Pine Island*, on the massive log walls of their home in Kleinburg, Ontario, they were obsessed with the desire to bring together a much larger collection of art with an unabashedly nationalistic flavour. "We fell under the spell of works by a few passionate artists who had captured not only the form and colour of the wilderness that we loved, but its very soul," he noted.[19] A professional photographer, he brought excellent promotion and marketing skills to the development of his collection, which in 1965 became a public art gallery, the McMichael Canadian Art Collection. Thomson and the artists of the Group of Seven remained their heroes, but in time they accommodated a wider spectrum of Canadian art and artists. As their collection grew, they acquired works from art donors such as Robert Laidlaw: he gave the gallery fifteen of the Thomson works he and his brother had owned as well as eight Thomson works McMichael persuaded him to buy for the collection as they became available.[20]

Altogether the McMichaels owned ninety-one works by Thomson, not counting artifacts such as an axe handle Thomson had carved. Although they were limited by what they could collect in an ever-narrowing market for Canadian historical art, their judgment is interesting because they literally lived with the work. Like Harris and MacDonald before them, they favoured Thomson's colour sensibility and bold design. Their favourite piece was *Black Spruce in Autumn* (page 87).[21] It reminded them of their close friendship with Margaret Tweedale, who donated the painting to the gallery in 1966.

Unlike McMichael, Ken Thomson, a billionaire who was regarded as one of the top ten art collectors in the world, was constantly revising and changing his collection, selling works he considered less important and buying new ones. Over several decades he built up an extraordinary collection ranging from medieval ivories and Chinese snuff bottles to masterpieces by Rubens, and he knew he could purchase almost any work of art he set his heart on at auction. He chose, however, to collect a large number of paintings by Tom Thomson.

Ken Thomson was particularly drawn to *Sketch for "Autumn's Garland"* (page 83). His love for any particular work was purely intuitive and heartfelt, and he rarely articulated

Preceding spread: detail,
Sketch for "Autumn's Garland" (page 83)

his reasons. In this painting he would have appreciated the fascinating and beautiful way Thomson harmonized colour and boldly delineated shapes, so that the composition is clamped in place by a concentrated buildup of paint laid on in small, specific touches to indicate leaves and trees around a centrally placed sapling. He liked to know the provenance of the pieces he collected, and he may have thought even more highly of this painting because it was once owned by George Thomson, the artist's eldest brother, who had studied at the Art Students League in New York.

Autumn, Three Trout was another sketch Ken Thomson valued.[22] It came to him from the artist's family, and it reminded him of Tom Thomson's own love for fishing. He likely admired the way Thomson captured the oval shapes of the trout in this composition, with their square, slightly forked tails and, on their sides, the small spots surrounded by halos. Other favourites included the spellbinding sketch *The Poacher*, whose unusual subject appealed to him (page 97), as well as the superb *Spruce and Tamarack*, which he sought over decades to acquire (page 117). *Pink Birches*, an early acquisition, always resonated with him (page 57), as did *Burnt Land at Sunset*, which he bought at auction in London, England (page 49).

In making their own careful selections of paintings by Tom Thomson, Robert McMichael, Ken Thomson, and a few other major collectors performed the same role for a later generation that Lawren Harris, J.E.H. MacDonald, and A.Y. Jackson did in 1918: they have provided a definitive point of reference for evaluating Thomson's entire oeuvre as an artist. As they immersed themselves in the work of this wonderfully skilled painter, these men discovered distinctive images and ideas about innovation that, once again, made it new.

Over time tastes change, and Thomson's reputation today has undergone a complex permutation. For many collectors, to own his work has become almost a proof of being Canadian. Others see important techniques in his paintings that have previously been overlooked by critics. One very knowledgeable collector believes, for instance, that

Thomson's definition of space and form in *Logging, Spring, Algonquin Park* is far in advance of similar attempts by many other artists (page 101). Yet another collector, with a fine curatorial acumen honed over decades of buying art and communicating with experts the world over, buys the best of Thomson's work whenever it appears on the market. His choices include paintings such as Thomson's brilliantly coloured and conceived *Northern Lights* (page 63).

Collections are often heavy with symbolism – wealthy newcomers to Canada, for instance, might buy a number of Victorian Canadian paintings as a way to put down roots. But expert, sophisticated collectors are not random accumulators; rather, they are very specific in their selections. They would not own the work of Tom Thomson unless it resonated – somehow – with their own spirit. To them, paintings by Thomson define something in their personal experience in so perfect a way that they become, as one of them said, "a language of one's own soul." They know that Thomson is extraordinary.

~

Detail, *Northern Lights* (page 63)

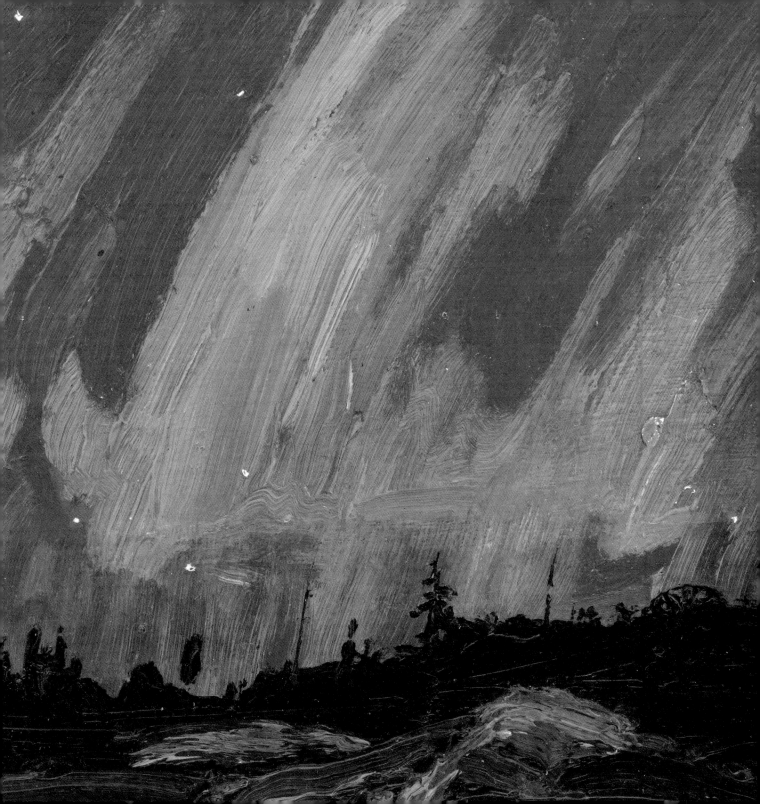

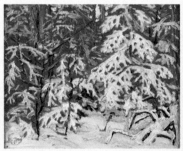

Winter Morning (page 41)
The sketch and its verso. The myriad inscriptions provide clues to the history of the painting.

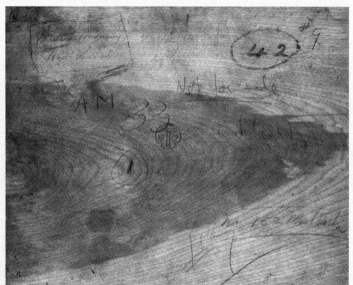

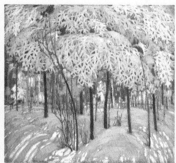

Snow in October (page 125)

The Back Story

Many Tom Thomson paintings have notes and gallery labels on their backs. *Winter Morning*, for instance, has sixteen notations on its verso, signalling right away that this sketch is important (page 41). To begin, it was signed and titled by the artist himself, in pencil. It is also stamped with the metal estate stamp J.E.H. MacDonald designed to authenticate the paintings Thomson left in the Studio Building. Other notations include "Spring 1915" in Dr. James MacCallum's writing and "Not for Sale" (underlined) in Lawren Harris's writing. There is a faint word that probably reads "Laidlaw," meaning that Harris had recommended it for purchase to his friends Walter or Robert Laidlaw. Mrs. Harkness, Thomson's older sister Elizabeth, wrote "No. 152" beside her name, indicating that the painting was in her care in the early days of the estate, and the circled "42" in red proves that it was part of the exhibition of the Laidlaw Collection in 1949. Other numbers indicate that the sketch was exhibited in many other shows as well.

The notations give us a valuable history of this painting. Thomson seldom wrote on the backs of his sketches, so we can assume that he saw something special in *Winter Morning* and intended to develop it later into a large canvas. During the winter of 1916 he created a

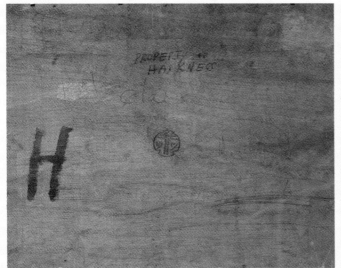

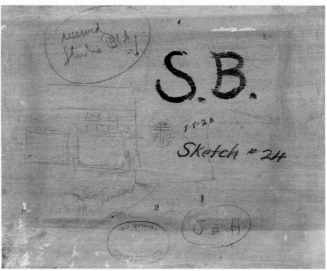

Wild Geese: Sketch for "Chill November" (page 115)
Harris wrote "1st class" on the verso. The details of the estate stamp are clear: a small palette with "TT" and "1917" on it.

Spring, Algonquin Park (page 95)
On the verso Harris or MacDonald wrote, "reserved / Studio Bldg." The impression of the estate stamp can be seen in the middle.

major painting on the subject, *Snow in October* (page 125). The other inscriptions trace the provenance of the sketch – from Harris's endorsement, through the family estate, and into the Laidlaw Collection.

After Thomson's death, his friends sometimes annotated the backs of his sketches with special information they had about the works. Dr. MacCallum attempted to date many of them and, from his memories of excursions with Thomson through Algonquin Park, commented on locations and circumstances in which they were painted. MacDonald wrote on the back of *Petawawa Gorges* that Thomson regarded it as his best sketch and wished to use it for a large painting (page 109).

In the four decades I have studied Tom Thomson's art, I have observed the loss of some of this verso information. Some inscriptions have faded through the passage of time or deliberate erasure. Gallery labels have fallen off, and inscriptions I once saw on the frame are missing, as are pieces of masking tape and cardboard or brown-paper backing. This disappearance is a sad memorial to the lack of understanding of the significance of such records.

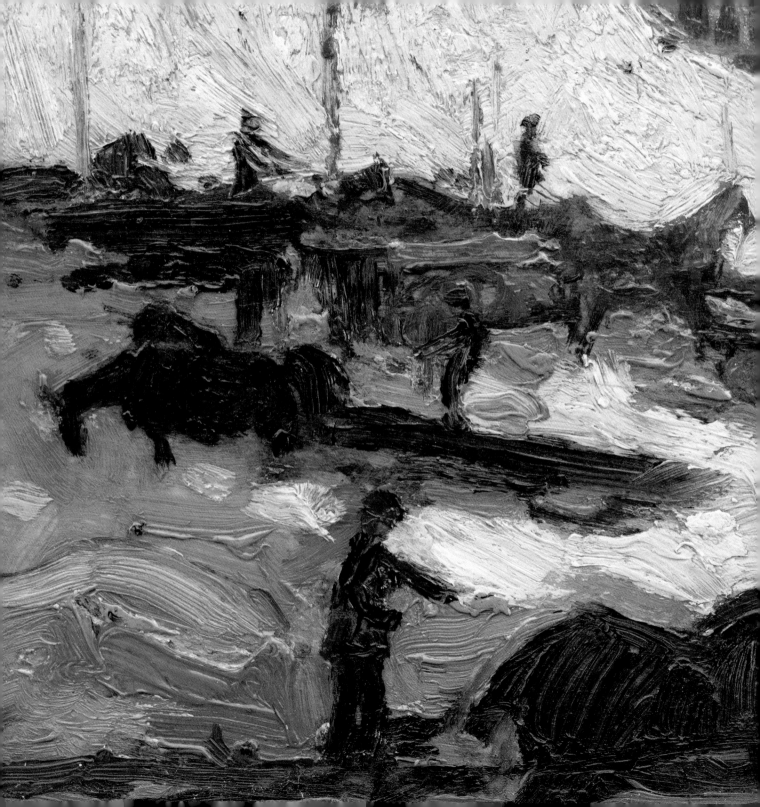

THE TREASURY OF PAINTINGS

Detail, *Logging, Spring, Algonquin Park* (page 101)

Autumn, Algonquin Park

fall 1914

In the fall of 1914 Thomson was joined in Algonquin Park by A.Y. Jackson, Fred Varley, and Arthur Lismer. It was the only time the four artists painted together in the park, and the heady experience of working together by day and discussing art into the evening had a huge impact on them all, particularly Thomson. It freed him to paint his impression of the scene directly before him in pure, clear colour. Already, the painters in this group, sometimes called the Algonquin Park School, were working to create an art movement that would portray the northern Canadian landscape in a new and distinctive way.

Thomson's enthusiasm to capture the essence of the natural world around him and his willingness to experiment to make that happen are evident in the variety of approaches he used in his sketches that fall. These paintings range from roughly textured, more sombre works to others painted with brighter colours, dotted with touches of red, orange, and yellow. To enliven these small sketches still more, he first applied ground colour as a base, then added other colours with short, quick strokes to capture his impression of the scene, and finally drew in branches or the shapes of trees. Thomson was using his training in design and commercial art, but, "no longer handicapped by literal representation, he was transposing, eliminating, designing, experimenting, finding happy color motives amid tangle and confusion, revelling in paint, and intensely interested," Jackson wrote. "Full of restless energy, the amount of work he did was incredible. There were long canoe trips, and we were up and out fishing at dawn. He seemed to require no sleep."[1]

In this beautifully designed sketch, Thomson drew on the audaciously flamboyant colour of the Canadian autumn, but he grounded the work with dark tints to create an eloquent vision of nature – sky, trees, changing light, and bush forms. Harris wrote "1st class" on the back, probably because of its mysterious mood.

Oil on plywood, 21.5 x 26.9 cm
Private collection

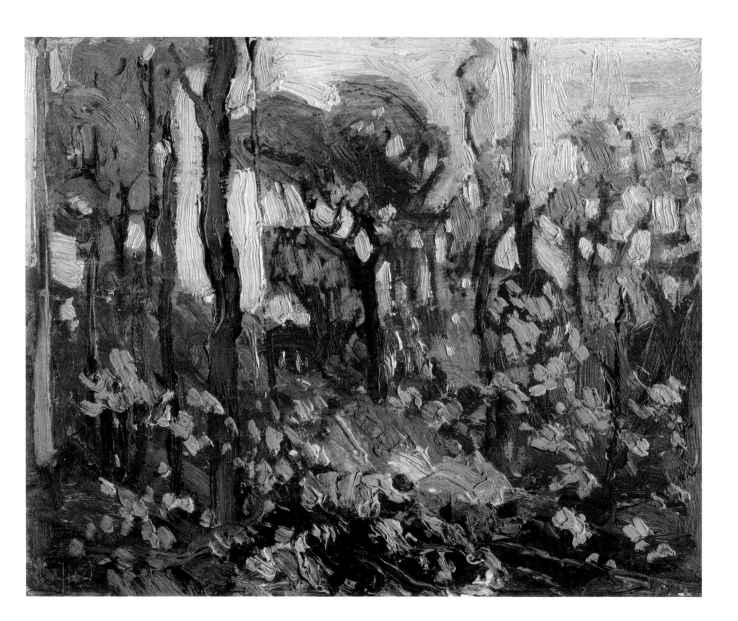

Northern River

winter 1914–15

During the winter of 1914–15, Thomson created a number of major paintings, such as *Pine Island, Georgian Bay* (National Gallery of Canada) and *Northern River*, in which he used an intricate surface design featuring the tracery of trees and branches. His interest in these decorative motifs was likely inspired by the exhibition of contemporary Scandinavian art that Harris and MacDonald had seen in Buffalo at the Albright Art Gallery in January 1913. They brought catalogues home with them, and MacDonald annotated his copy and showed it excitedly to Thomson and the other members of their group.[2] The international art magazine *The Studio*, which they read, had also published articles on Scandinavian art.

Thomson increasingly used decorative elements in his work – often those that reflected his training in design, such as his knowledge of Art Nouveau. Here he used the motif of a screen of foliage in the foreground of the canvas, which framed the scene beyond. *Northern River* was purchased by Eric Brown, the director of the National Gallery of Canada, for $500 in 1915 – during Thomson's lifetime. Harris and MacDonald would no doubt have agreed on its importance, particularly for the way Thomson used a darkened foreground of trees and shoreline against the well-lit background. In a letter to Dr. MacCallum in 1915, Thomson had called the painting simply his "swamp picture." He told his nephew, however, that he thought it "not half bad."

Thomson, who loved poetry, may have taken the title from a poem by William Wilfred Campbell, who had attended school in Owen Sound, close to the Thomson family farm at Leith, and still visited there regularly.

Oil on canvas, 115.1 x 102.0 cm
National Gallery of Canada, Ottawa
Purchase, 1915 (1055)

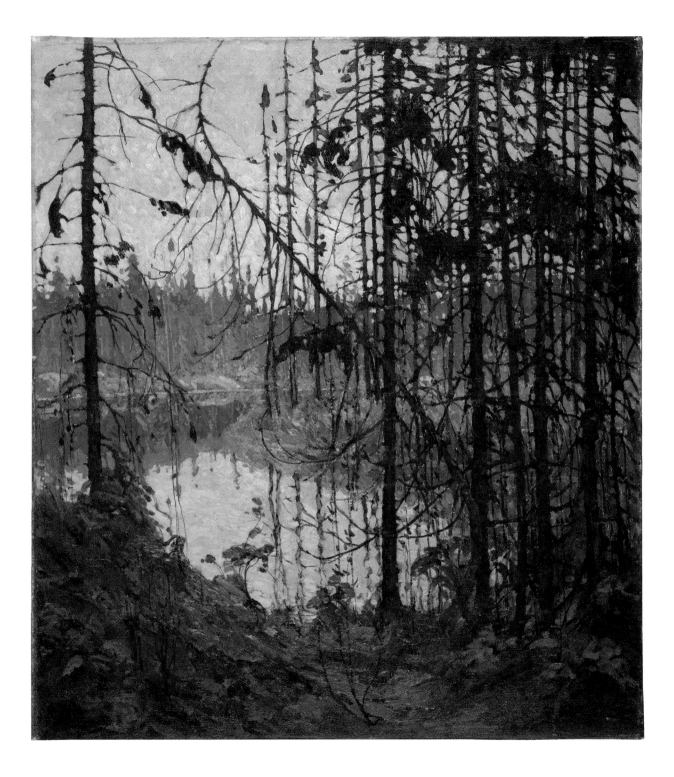

Burnt Land

spring 1915

Lawren Harris acquired this small painting from Thomson late in 1915 when Thomson was back in Toronto from Algonquin Park and working in the Studio Building. Thomson may have given it to Harris, or Harris may have purchased it.

Harris would have found the sketch interesting because of the way Thomson forcefully depicted a typically northern subject – "burnt-over" land – and used a boldly photographic "cut-off" view. In contrast to other canvases he painted that winter, such as *In Algonquin Park* (McMichael Canadian Art Collection), Thomson's concern here was not so much with colour and the creation of a complex surface pattern as with simplicity of composition. What counted was the contrast between the disorganized mass of dead trees, logs, and bush in the foreground, which he painted with a heavy surface in rich colour, and the evenly painted background hill and sky. The little pine tree, slightly off-centre at the left, forms a tremulous focal point. The result – with its blues, greys, oranges, and greens – is powerful.

Harris deeply valued the work and sold it to the National Gallery of Canada for $1,000 in 1937, after he had moved to the United States and become an abstract artist. Clearly it was of great significance to him because of its composition and his warm memories of Thomson.

Oil on canvas, 54.6 x 66.7 cm
National Gallery of Canada, Ottawa
Purchase, 1937 (4299)

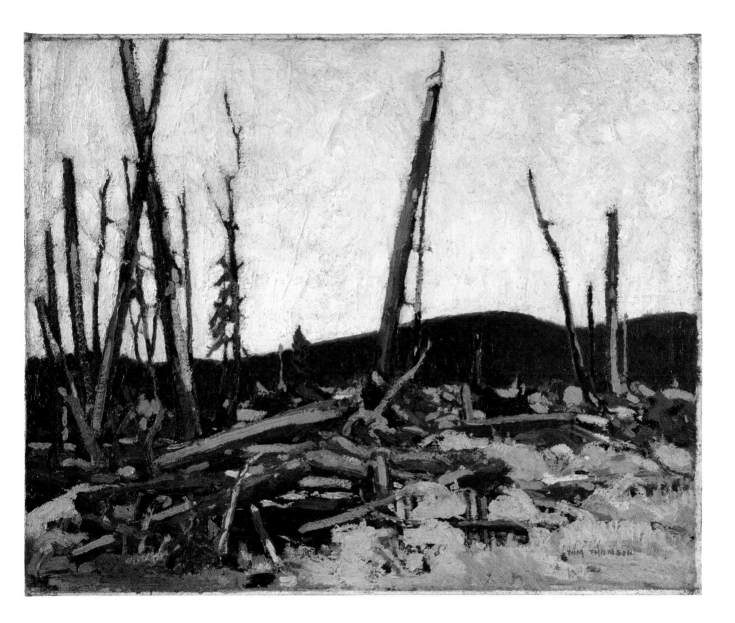

Snow in the Village

spring 1915

On April 22, 1915, Thomson wrote from Mowat Lodge on Canoe Lake to his friend and patron Dr. MacCallum. He had stayed in Huntsville for two days in mid-March, he explained, before travelling to Algonquin Park, where he had been ever since. He told MacCallum he had made quite a lot of sketches – some twenty-eight already.[3]

This tranquil townscape may be of a house in Huntsville, perhaps on the street where Thomson's friend Winnifred Trainor lived with her family.[4] Technically, the sketch belongs in the Modernist tradition of forthright, simplified painting so characteristic of Thomson. In it he used a specific compositional motif – the shadow in the foreground, which is cast by something located in the viewer's space, in this case a house. It lends a dramatic touch to the composition and, like the shadows cast by trees in his woodland paintings, intensifies the feeling of space in the work. It also helps to make viewers feel that they are a part of the scene.

The clear light in this sketch, as in those Thomson painted in nature, suggests the immediacy of a lived experience. He included a passerby in the middle ground who seems to face away to look at the houses, thereby reinforcing the viewers' interest in them.

The painting is a favourite of one of the more recent collectors of Thomson's work. We do not know its early history, but it would not have been selected by Harris or MacDonald simply because of its subject – they viewed Thomson essentially as a pioneer of northern landscape painting.

Oil on paperboard (Birchmore board), 22.9 x 17.8 cm
Thomson Family Collection

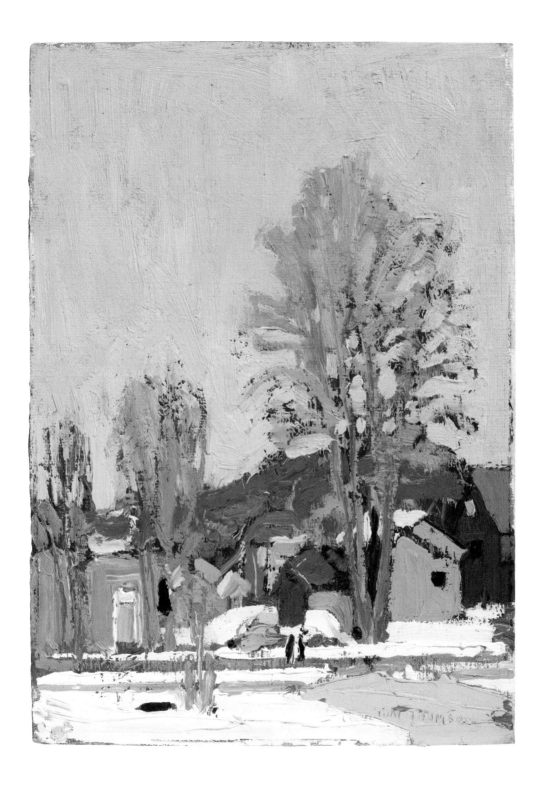

Winter Morning

spring 1915

Thomson arrived in Algonquin Park about the middle of March 1915. He was eager to paint snow subjects, and the snow in the woods was two to three feet deep.[5] He painted this sketch before April 28, the day he left to guide a fishing party from Pittsburgh.[6] The sketch shows the heavy snow on the ground and the trees in a tight, enclosed space, which Thomson opened at the top by adding touches of yellow to suggest the light of early morning.

In the body of the scene, Thomson used blues and greys to create the sense of an intricate, structured world. The touches of dark ultramarine (the most expensive paint colour) pick out the details. Elsewhere he used browns and black to establish the verticals of tree trunks and pockets of shadow. Thomson returned to this subject in the fall of 1916 and, that winter, created a major canvas, *Snow in October* (page 125).

Thomson usually left his works unsigned and without titles, but he added both his signature and a title to this one. The many marks on the back of the sketch also suggest its significance. After Thomson's death Harris wrote "Not for Sale" on it, underlined, and "Laidlaw." Clearly he was reserving it for his friends Walter and Robert Laidlaw, who included it in a group of twenty sketches they purchased. Others also wrote on the back, including Dr. MacCallum, who recorded when it was painted, and Mrs. Elizabeth Harkness, Thomson's sister, who handled the estate. Some marks indicate exhibitions at which the work was shown – such as the circled "42" in red, indicating it was number 42 in an exhibition of the Laidlaw Collection in 1949.

Oil on wood (verso has a bevelled edge), 21.5 x 26.6 cm
Private collection

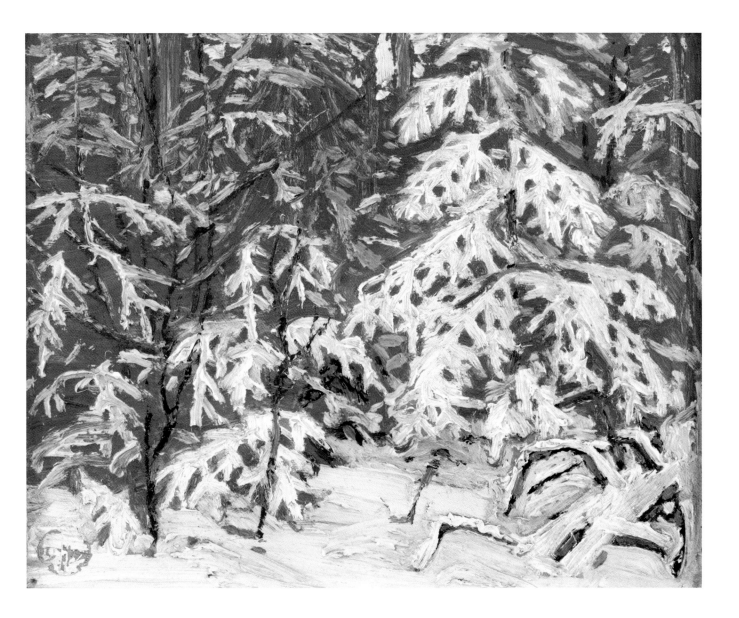

Wild Cherries, Spring

spring 1915

Thomson was fascinated by light, and he recorded it in many variations, often painting the sky of dawn or evening, of sunsets or moonlight. Clearly he was experimenting with colour and brushwork as he did so. The best of these works have a rapturous quality, as though Thomson was using light to introduce a seductive slash of yellow or orange to his sketches – a welcome, colourful addition to the scene before him.

In this painting he used a full brush and applied the paint in quick, broad strokes. The movement he captured in the sky and the special depth in the centre show his skill in painting and design. The sketch has a private, sequestered feeling – of someone observing the scene within moments of waking from sleep. In May 1915 Thomson painted three different sketches on this theme: *Wild Cherries, Spring*; *Wild Cherry Trees in Blossom* (page 45), and, a moodier evocation, *Wild Cherry Trees in Blossom*, today in the Thomson Collection at the Art Gallery of Ontario. Here, in this section of burnt-over landscape in Algonquin Park, he found magic in the new growth of the cherry trees – a theme that simultaneously suggests birth and death. By combining the subject of dawn with the bursting forms of the trees, Thomson suggested that, for him, light and growth are interwoven with the promise of spring.

Lawren Harris gave the sketch his wholehearted approval, marking it "1st class."

Oil on composite wood-pulp board, 21.6 x 26.7 cm
McMichael Canadian Art Collection, Kleinburg, Ontario
Gift of the founders, Robert and Signe McMichael, 1966 (1966.16.72)

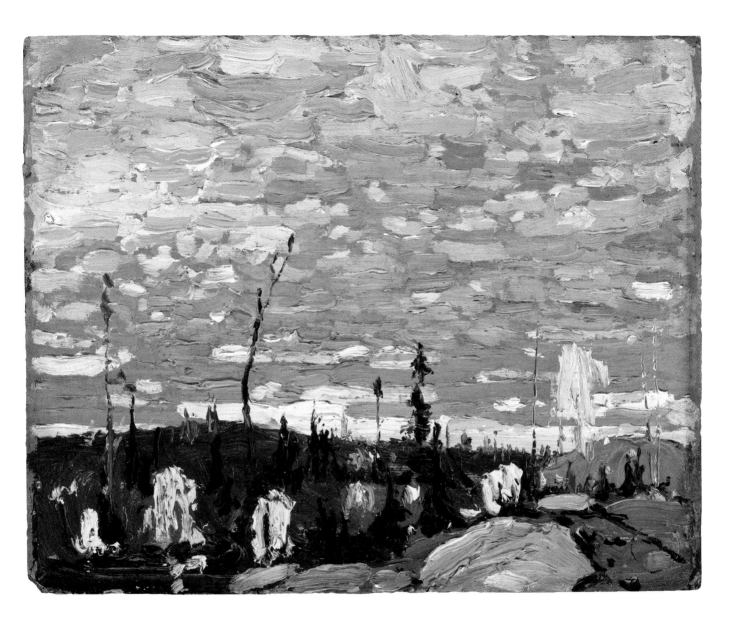

Wild Cherry Trees in Blossom

spring 1915

This sketch of wild cherry trees, like *Wild Cherries, Spring* (page 43), received Harris's stamp of approval: again on the verso he wrote, "First class." Later he also advised the Art Gallery of Toronto (now Art Gallery of Ontario) to buy this exceptional work, full of movement and life. It reflects Thomson's infallible feeling for composition and radiant, though subdued, colour, as well as his skill in rendering the beauty of spring in the north country. In contrast to the land-bound *Wild Cherries, Spring*, Thomson focused in this painting on wild cherry trees on a hillside overlooking a stream, which, during the spring runoff, became turbulent eddies of water swirling in an oval in the foreground.

Thomson excelled at recording movement, and he did so here with particular zeal. The vigorous current forms a portrait of the artist – living, working, restless, and energetic. In 1915 Thomson was often on the move himself or else thinking of travelling. This sketch, and *Wild Cherries, Spring*, were painted after his return from guiding a fishing party in late April and early May, and, because he had few other bookings, he was considering making other canoe trips or going west to help with the harvest. His choice of subject – the swirling waters and blossoming trees – may well have reflected his inner turmoil at this time.

Oil on composite wood-pulp board, 21.6 x 26.7 cm
Art Gallery of Ontario, Toronto
Gift from the Reuben and Kate Leonard Canadian Fund, 1927 (850)

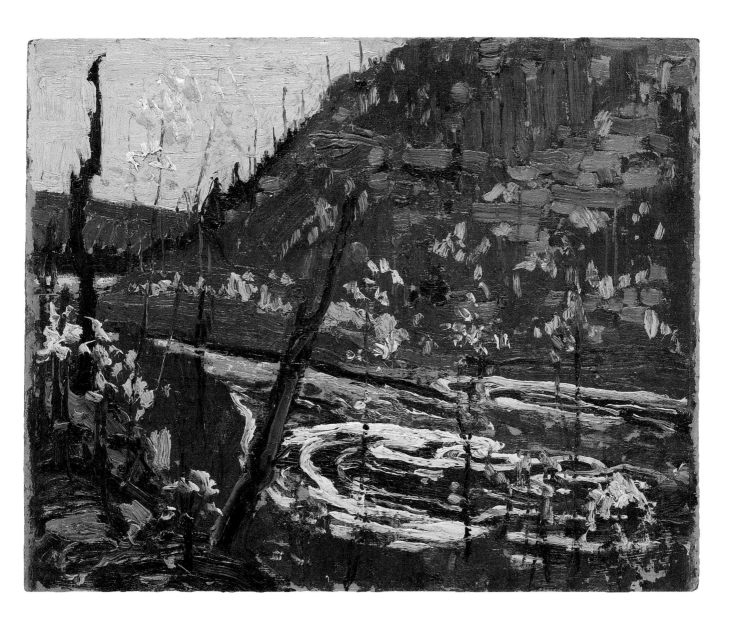

Burnt Land

spring 1915

Harris wrote "1st class" on the verso of this strongly conceived sketch, with its grand and gripping vision of a burnt-over area in Algonquin Park. Later he may have thought of this composition as he painted his well-known canvas *Algoma Country* (c. 1920–21), now in the Art Gallery of Ontario. The shape of the small hill in the foreground and the depth in both paintings seem similar.

Robert McMichael, who brought this work to his final meeting with the Collection Committee of the McMichael Canadian Art Collection in June 1981, thought it superb, but, to his surprise, he found it a hard sell. The painting came from Alan M. Cameron of Sudbury, along with Thomson's sketch *Petawawa Gorges*, today also in the McMichael Collection (page 111). McMichael believed the acquisition of these two fine works would be a fitting climax to his term as chief executive, and he was stunned when one of the trustees asked, "Do we need any more Tom Thomsons?"[7] Fortunately the other trustees moved to approve the purchase.

The sketch is an important one, as McMichael realized. From this painting, with its fiery red and gold foreground trees, Thomson extracted an apocalyptic theme, tempered by the clouds that soar overhead. He must have relished a subject that could be painted to look, simultaneously, both representational and abstract. There is also an ebullient quality to his use of colour, particularly in the small touches of reds and purples he applied to the logs and brush in the foreground, the distant hills, and the menacing clouds.

Oil on wood panel, 21.4 x 26.8 cm
McMichael Canadian Art Collection, Kleinburg, Ontario
Purchase, 1981 (1981.91)

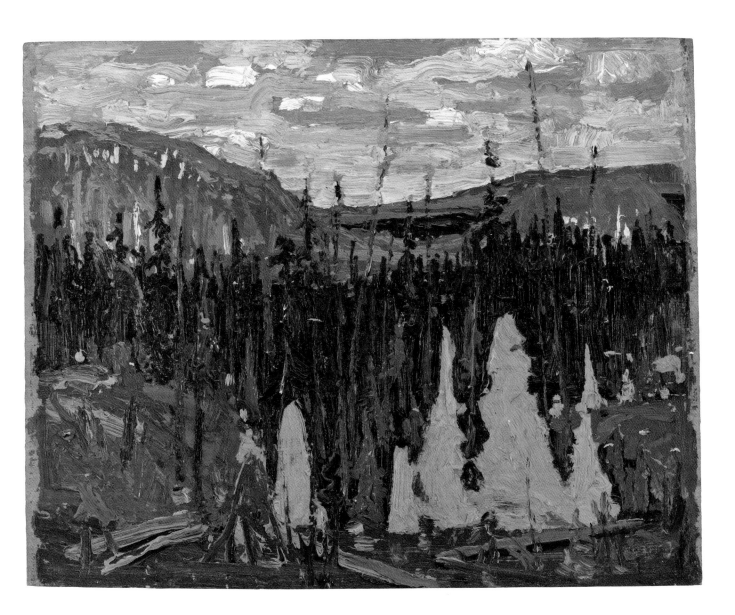

Burnt Land at Sunset

summer 1915

Lawren Harris knew this sketch was a beauty. His inscription on the verso reserves it for one of his friends: "Reserved / III bob Laidlaw / per / Lawren Harris / IV McLennan / II Robson / [Gordon?] Davis" (the numbers indicate the order of preference among the Thomson sketches these friends had selected). Ultimately businessman Frank Porter Wood (1882–1955) purchased the painting. His collection included European masterpieces by artists such as Rembrandt, Van Dyke, and Gainsborough. In 1955 Wood donated many of these paintings to the Art Gallery of Toronto (now Art Gallery of Ontario), but he kept this sketch. It came to auction only in 1998 at Christie's London.

During the summer of 1915, Thomson travelled extensively in Algonquin Park. He wrote to his friend Dr. MacCallum in September that the area around South River was fine country for painting and that some of the land was "mostly burnt over," as in this sketch of skeletal trees and fallen logs. The message in the work could have been dark, but the sky, aglow at sunset, transfigures the scene. Thomson played here with contradictions – death, life / dark, light – and the sketch is visually fascinating. He applied coral paint as the ground, and small patches show through the surface paint, contributing to the effect of radiant colour.

Oil on composite wood-pulp board, 21.6 x 26.8 cm
Thomson Family Collection

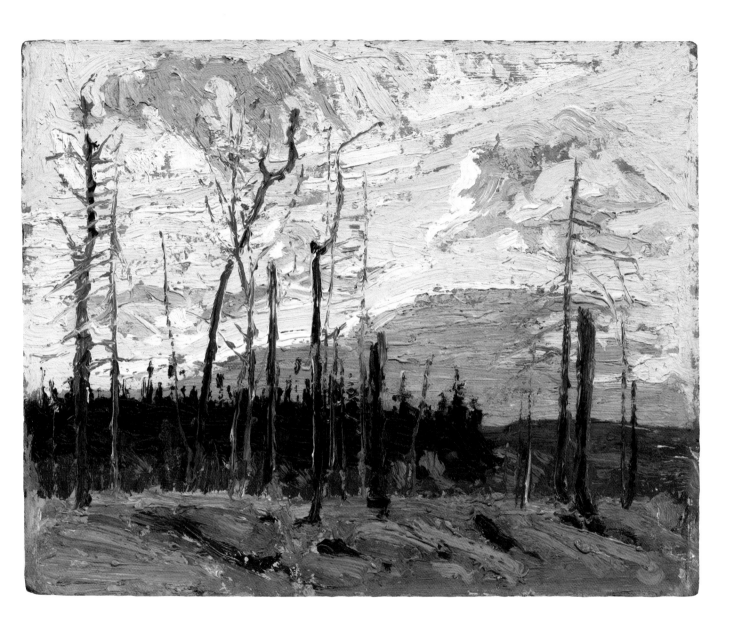

Marguerites, Wood Lilies and Vetch

summer 1915

On the verso of this sketch MacDonald wrote, "Not for Sale / J.E.H. Macdonald." This glowing sketch was not on Harris's list of favourites, but for a painter such as MacDonald, who loved to paint flowers and enjoyed their rich colour, the effect of this woodland bouquet would have been magical.

Curiously, the composition of the sketch is similar to that of *Burnt Land* (page 47): the viewer looks over an element in the foreground, here a red wood lily, into the heart of the sketch, defined by a daisy and vetches. Along with the superb and brilliant colour, the simplified forms and firm handling suggest that Thomson was delighted with the way nature had created a subject for him – one he discovered, perhaps, walking in the woods. He filled in the black background after he finished painting the flowers, giving them even more vibrancy.

The sketch must have been important to Thomson, as it is among the few works he annotated himself. On the verso he wrote, "Study of Wild Flowers Tom Thomson." A label there identifies the three flowers that make up the title. MacDonald selected it for himself from among the works by Thomson stored in the Studio Building in Toronto, and he owned it for several years.

Oil on wood, 21.4 x 26.8 cm
Art Gallery of Ontario, Toronto
Gift from the Albert H. Robson Memorial Subscription Fund, 1941 (2563)

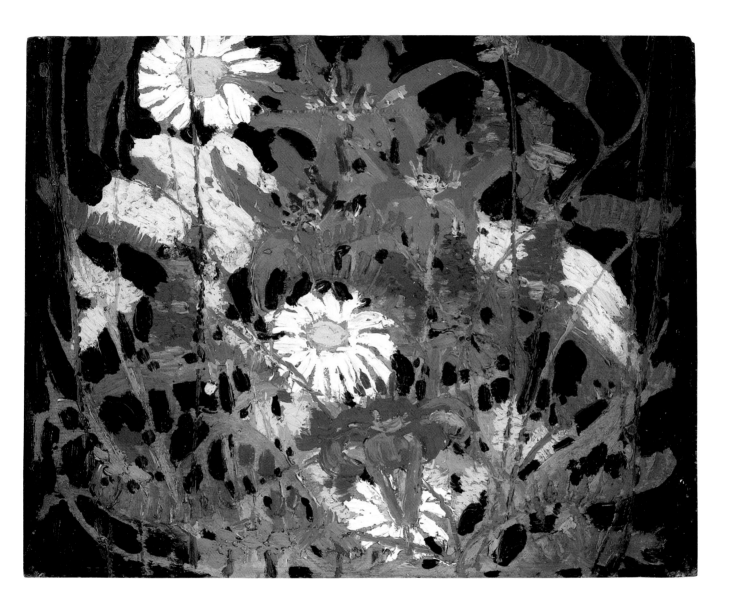

Wildflowers

summer 1915

Wildflowers made Harris's list of favourites in the large cache of paintings in the Thomson estate: on the verso he wrote, "1st class." In 1970 Robert Laidlaw purchased it from Thomson's sister Margaret Tweedale and gifted it to the McMichael Canadian Art Collection. In all, he gave twenty-three works by Thomson to the gallery.

Although the colour is not as brilliant as that in *Marguerites, Wood Lilies and Vetch* (page 51), the brushwork in this sketch contributes to a lucid description of the flowers. Thomson's palette is handsomely coordinated – blues are set against yellows, and the reds of the flowers in the bottom half of the work play off against the whites of the daisies.

Thomson was stimulated primarily by the movement of the natural forms, and he simply applied black to indicate the background. He likely drew what he saw before him and omitted little. At the centre, the delicate grasses cross, and throughout, the skewed shapes add to the vitality of the work. Once again Thomson used his paint sparingly and allowed the wood of the surface to show through, adding an appealing freshness to the sketch. The image is one of bustling business, bursting growth, and delight.

Oil on composite wood-pulp board, 21.6 x 26.8 cm
McMichael Canadian Art Collection, Kleinburg, Ontario
Gift of R.A. Laidlaw, Toronto, 1970 (1970.12.2)

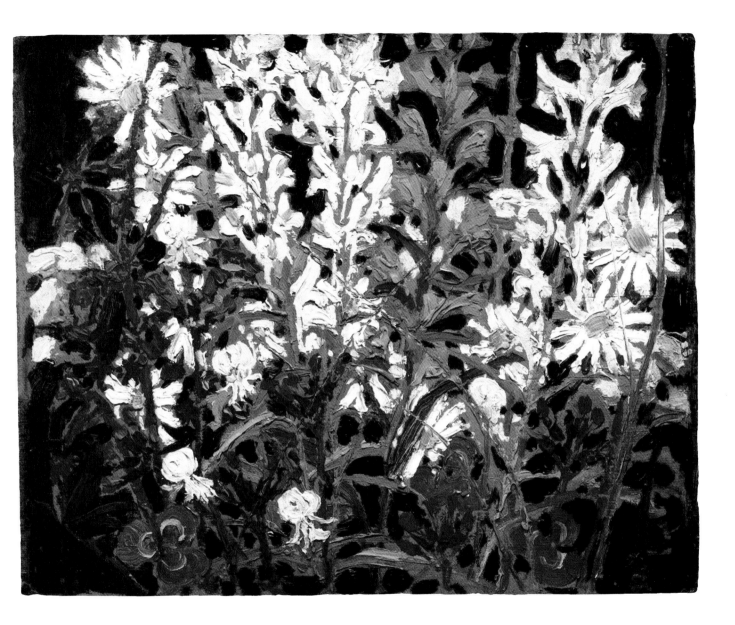

Water Flowers

summer 1915

In *Water Flowers* Thomson mused on the theme of flowers, interpreting it loosely and portraying the plants as he saw them in nature. Recognizing the importance of the sketch, MacDonald wrote on the back, "Not for sale."

Thomson would likely have discovered these flowers while paddling his canoe and been struck by the powerful composition they presented. He discreetly suggested their forms in the sketch, without much detail or representation. Various people have tried to identify the flowers, and someone wrote on the back of the panel in graphite, "Pickerel Weed / White Waterlilies / Yellow Lilies." When the sketch was exhibited in 1919 it appeared under the title "Water Plants (lilies, cats' tail and water hyacinth)." The painting's strange, moody ethereality comes mostly from its black background and flat, abstracted shapes.

Someone has written the year "1916" on the back. The sketch may well have been painted then because, that year, Thomson often sketched on wood panels, and he continued to paint flower studies the following spring and summer. However, the palette fits with other works from 1915, so the painting may also date from then. Flowers may have reminded Thomson of his father, John, who loved his half-acre garden plot at Rose Hill farm in Leith, Ontario. He grew a little of everything but mostly a rich selection of flowers. One acquaintance remarked, "He painted a picture" in his garden.

Oil on wood, 21.3 x 26.7 cm
McMichael Canadian Art Collection, Kleinburg, Ontario
Purchase, 1976 (1976.20)

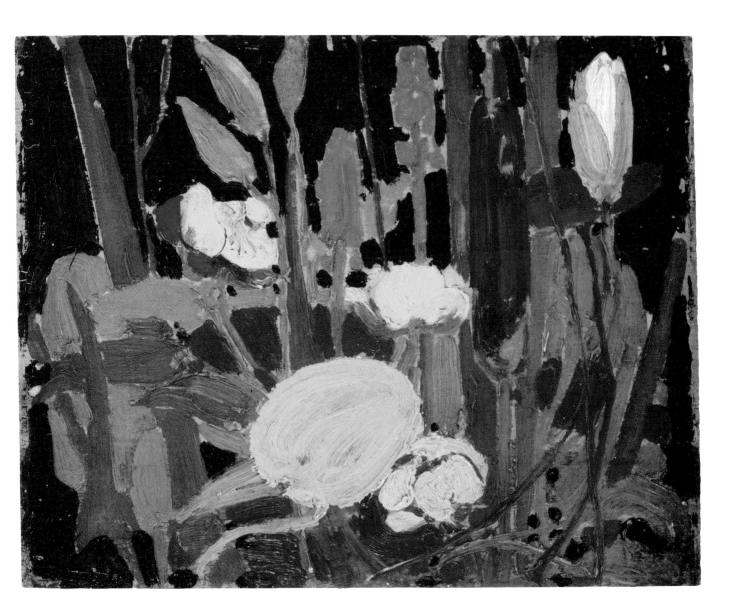

Pink Birches

summer 1915

Pink Birches once belonged to Professor J.S. Lawson of Victoria College at the University of Toronto. He must have been very close to Thomson's circle of friends because he owned not only this important and beautiful sketch but also another dazzling work by Thomson, *Marguerites, Wood Lilies and Vetch* (page 51), as well as the major canvas *Opulent October* (private collection). Dr. MacCallum may have been the person who wrote "NG" (for National Gallery) on the back, designating the institution he thought should own it. He was certainly the one who quibbled over the date, changing 1916 to 1915 on the verso and adding "AUG" to suggest the month in which it was painted.

Thomson had used a similar view of water between stylized birches perhaps around 1913, in an advertising or calendar drawing he produced in ink on cardboard. He used a similar composition and palette in a later canvas, *Decorative Landscape: Birches*, which is in the National Gallery of Canada. This sketch demonstrates that Thomson reworked his ideas to create fresh images as well as the large canvases he painted in his studio. The brilliant colour sharpens our appreciation of the full range Thomson discovered in nature in Algonquin Park and the imposing way he was able to capture it in a small work.

Oil on composite wood-pulp board, 26.7 x 21.6 cm
Thomson Family Collection

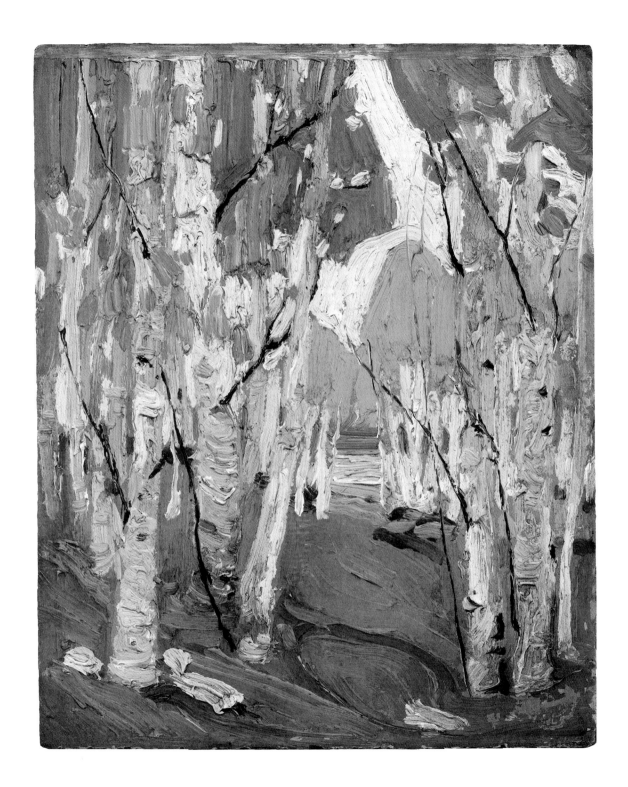

Lightning, Canoe Lake

summer 1915

The works Harris and MacDonald chose as their favourites revealed Thomson's brilliance as a designer and colourist as well as his keen appreciation of Canadian nature. On the verso of this work MacDonald wrote, "Not for Sale." Dr. MacCallum, who owned this sketch, also wrote on the verso: "Lightning and thunder Storm, Canoe lake 1915. J. MacCallum."

This sketch is the only work in which Thomson painted lightning. Everything in the storm seems to take place in an atmospheric haze – an effect Thomson created by lightly applying, if not scraping, a layer of blue paint over the ground layer composed of different purples and blues. He also used subtle touches of colour to indicate sunlight underneath the cloud at the top of the work and on the hill in the distance to the right. In this way, he suggested the quick weather changes in Algonquin Park.

Thomson seems to have painted this scene directly from nature. He may have been in a canoe, looking up at the sky from the centre of a lake, because he gives no indication of a shoreline in the foreground. He could also have painted it from the shore and, to focus the sketch sharply, omitted the place on which he stood.

The short brushstrokes, painted with great speed, feel contemporary. Although Thomson was thirty-seven when he painted this sketch, he had found his feet as an artist just the previous autumn, in the company of his friends. Already he was at home with his palette, his surfaces, and his way of evoking the natural world.

In 1990 Ian Thom, senior curator at the Vancouver Art Gallery, chose this sketch as the cover illustration for a Thomson exhibition booklet for the gallery.

Oil on plywood, 21.5 x 26.7 cm
National Gallery of Canada, Ottawa
Bequest of Dr. J.M. MacCallum, Toronto, 1944 (4678)

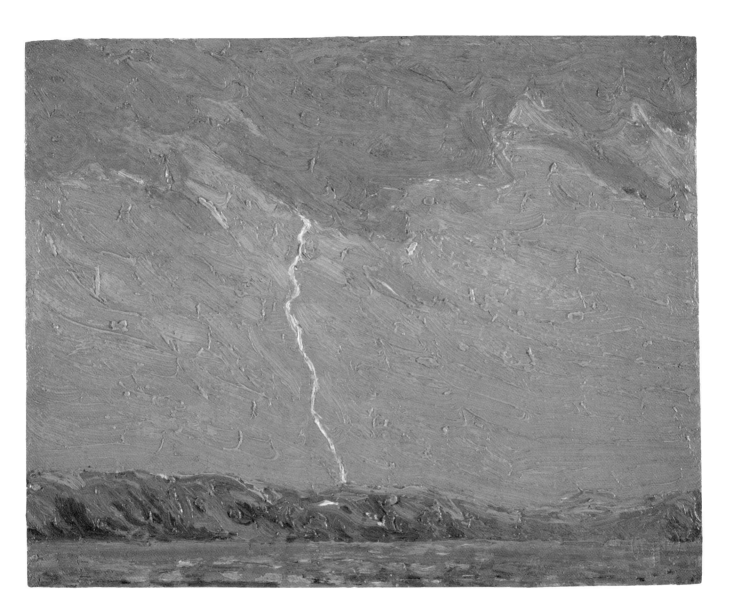

Morning

summer 1915

On the verso of this sketch Thomson wrote, "Morning," and signed his name. He rarely inscribed his work, so he must have thought this painting was special. In this panel, through his impassioned handling of paint, he captured the radiant light of early morning and the soaring shapes of the clouds as they drift over the quiet waters of the lake. He likely painted the subject at dawn from his canoe.

MacDonald also found the sketch to be very good. He wrote on the verso, "Not for Sale," to reserve it for friends among the circle of artists and collectors he knew. A.Y. Jackson, the first person to share a studio with Thomson in the Studio Building in Toronto, may have wished to own this painting because he wrote on the back, "AYJ; SB" – that is, "A.Y. Jackson; Studio Building." However, he ultimately decided that *The Rapids* was the sketch for him (page 141).

Oil on composite wood-pulp board, 21.5 x 26.5 cm
Tom Thomson Art Gallery, Owen Sound, Ontario
Bequest of D.I. McLeod, 1967 (967-040)

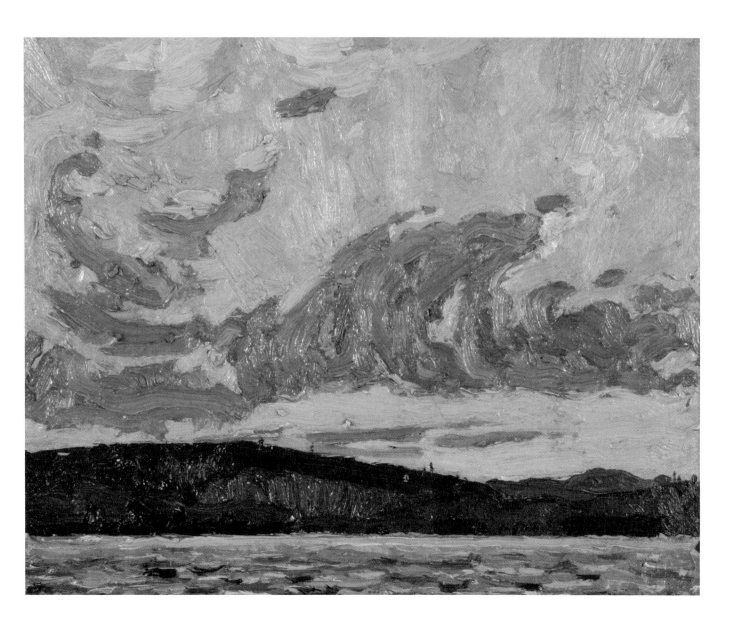

Northern Lights

summer 1915

Tom Thomson painted both sides of this panel: *Northern Lights* was on one side and *Smoke Lake* (McMichael Canadian Art Collection) on the other. He gave it to Thoreau MacDonald – proof that he valued it highly. Thoreau was the son of J.E.H. MacDonald, the senior artist in the design section at Grip Limited in Toronto and Thomson's boss. Thomson and Thoreau had become friends as they met frequently when Thomson visited MacDonald at home outside office hours to help with design jobs.

Thomson painted five sketches of *Northern Lights*, a subject of special fascination to anyone interested in northern nature. The green and turquoise of this panel, the rich pattern of the trees on the hillside, and the way the foreground rock is firmly outlined give it a special liveliness. Thomson clearly found a poetic quality in this subject – the battle between light and dark.

W. Donald Patterson, who purchased the painting in 1934 or 1935, showed it to Robert McMichael in 1967. McMichael asked if he could have the work split and keep the secondary side, which was marked with a big "X" through it, for the gallery. He explained it could be a centennial gift from Mr. Patterson and his wife, and *Northern Lights* would still belong to them. They agreed.

Eduard Zukowski, who worked at the Art Gallery of Ontario, split the panel and cleaned the surfaces of both sides. He also removed the "X" from *Smoke Lake*. In 2006 the heirs of the Patterson estate were uncertain whether their sketch was by Thomson, so they brought *Northern Lights* to the author, who was then interim executive director of the McMichael Canadian Art Collection. When they were assured about the authenticity of their work and shown its other half, they placed it at auction, where the present owner purchased it.

Oil on panel, 21.6 x 26.7 cm
Thomson Family Collection

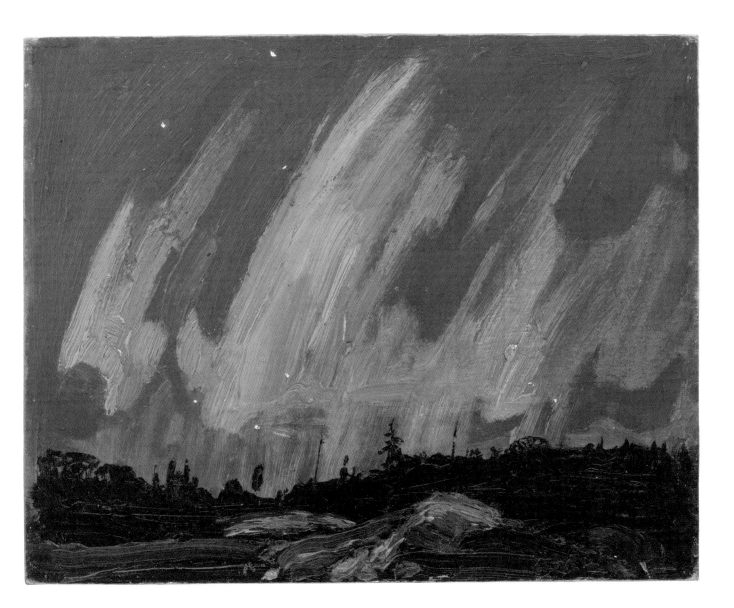

Pine Trees at Sunset

summer 1915

A technique that is often used in painting and photography to great effect is to delineate dark shapes against a highly lit background, thereby forcing the viewer to look beyond the foreground. This particular device is called *contre-jour*, a French phrase meaning "against the daylight." It was used by several of the Group of Seven artists, particularly Lawren Harris. In this sketch Thomson experimented with the idea to create a beautiful picture with a rich painterly surface.

The brilliant yellows and oranges in the sketch help to ignite the sombre blacks and browns. The shapes of the pine trees achieve monumentality in this sketch. The result is at once superbly skilful and quietly restrained – an effective balance that encourages both looking at the painting and thinking about it.

Thomson's friends would have realized that this sketch, with its sensuous evocation, was outstanding. It must have sold to a collector at an early date because on the back there are no markings by Thomson's relatives or by dealers. Without doubt it is one of the most memorable of Thomson's little paintings.

Oil on composite wood-pulp board, 26.7 x 21.0 cm
Thomson Family Collection

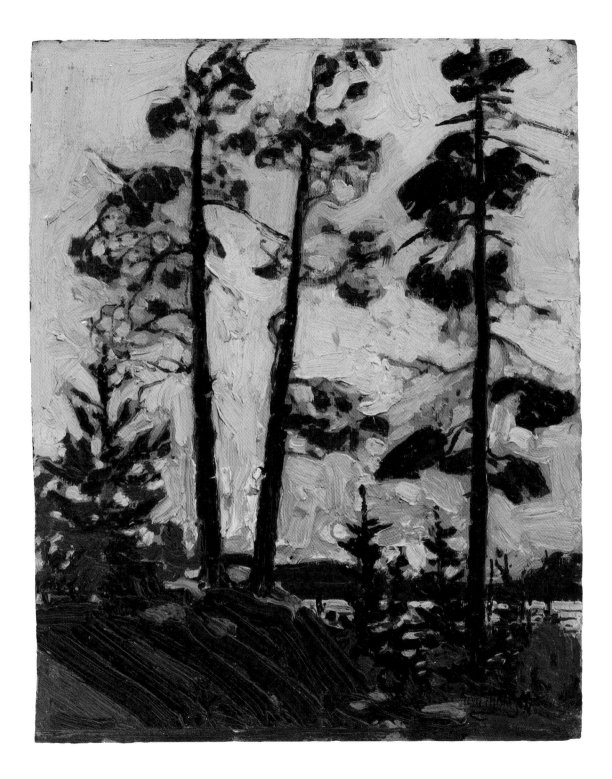

Ragged Lake

fall 1915

On the verso of this panel MacDonald wrote, "Not for sale." W.C. Laidlaw purchased it from the Thomson estate, which was then being handled by the artist's sister Margaret Tweedale, and bequeathed it to his brother R.A. Laidlaw. The next owner was Mrs. G.Y. Douglas, who, in 1963, donated it to the Art Gallery of Hamilton. This painting had other titles as well, including "A Northern Lake," which is written on the back, and "Ragged Creek."

As in other works by Thomson, the viewer looks at a particular scene in Canada's northern landscape. Its beauty lies in its suggestion of a peaceful morning or afternoon in Algonquin Park, a day of sweeping clouds and windy weather. In the foreground, the fallen tree at the right and the trees on the left frame the islands in the background. Again, there are only the briefest indications of shoreline in the foreground, and the observer may wonder if Thomson painted the sketch while he sat in his canoe on the lake.

Here Thomson has captured myriad visual riches in the simplest possible way. The brushwork is made up of small jabbing strokes that indicate the shapes of clouds, trees, rocks, and water. The coloration is very close to that of the northern landscape during the peak fall months. The overall effect is captivating but modest and without bravado.

Oil on panel, 21.2 x 26.2 cm
Art Gallery of Hamilton
Gift of Mrs. G.Y. Douglas, 1963 (63.112.U)

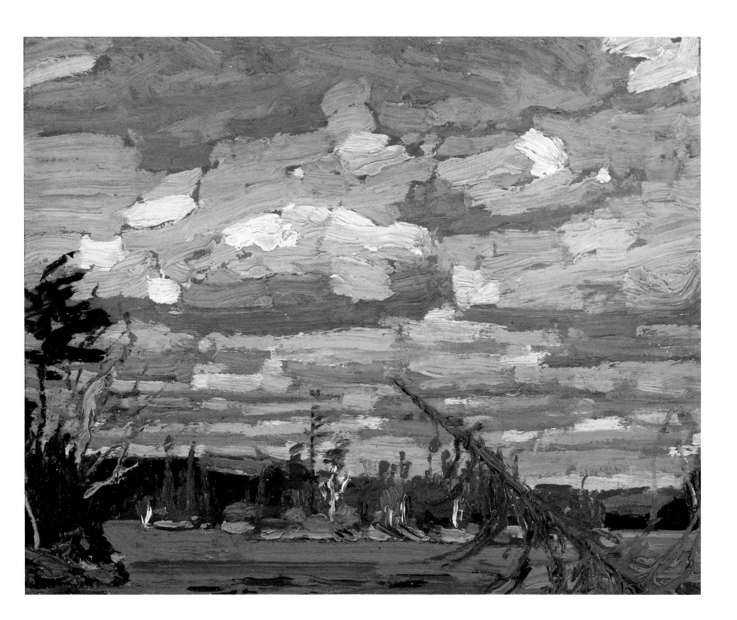

Approaching Snowstorm

fall 1915

MacDonald wrote on the verso of this painting, "Not for Sale," to reserve it for himself or his friends. A second inscription reads "M. Thomson," so the sketch may have been owned by Margaret Tweedale, Thomson's sister. Perhaps it came from her to Dr. MacCallum, who recognized it as one of the best of Thomson's works. He arranged for it to be donated to the National Gallery of Canada after his death.

Thomson excelled at small but monumental depictions of the natural landscape. His art was based on design in its largest sense – the point where balance meets the irregular. Here a heavy cloud of snow swirls over the land of Algonquin Park, but Thomson has enhanced that sense of weight by indicating that, in the distance, there are clearer skies. This technique is often found in Victorian art, and it was also used by Lawren Harris, Franklin Carmichael, and other painters in Thomson's circle. Thomson has rendered the clouds and the sky with great visual clarity. This work is one of his most popular, and it often appears in essays on the four seasons in Canadian art.

This sketch may have reminded Harris of a storm he experienced with Thomson in the spring of 1916, as they hid out in an abandoned lumber shack. "When the storm broke," he wrote in a letter at the time, "[Tom] grabbed his sketch box, ran out into the gale … and commenced to paint in a fury … In twenty minutes [he] had caught in living paint the power and the drama of storms in the north."[8]

Oil on wood, 21.3 x 26.6 cm
National Gallery of Canada, Ottawa
Bequest of Dr. J.M. MacCallum, Toronto, 1944 (4689)

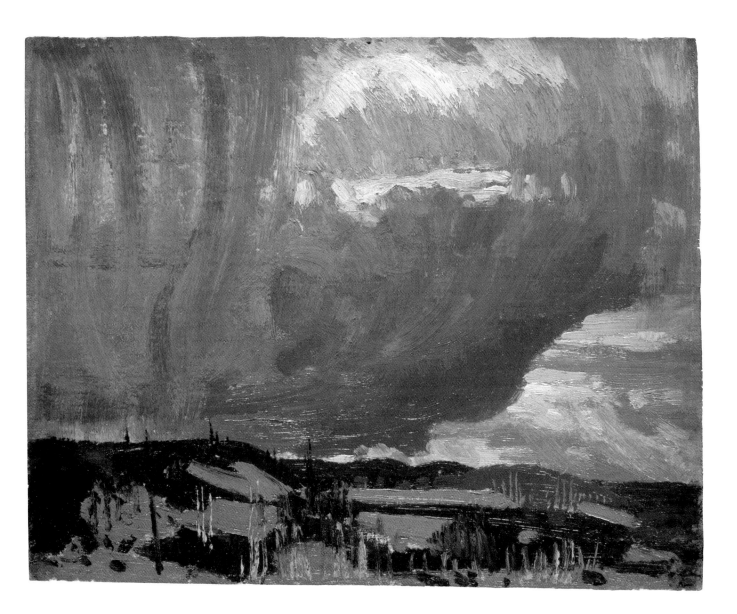

Moonlight

fall 1915

What is valuable in this painting is its sense of engagement with nature during the moonlit hour. Tom Thomson developed the sketch into a canvas, which is now in a private collection. Both the sketch and the final canvas have a mysterious, elusive mood, though the sketch is painted far more boldly.

Thomson's brief career as an artist began and ended in the wake of a convergence of early twentieth-century painting styles that today are called Tonalism. The American art critic Charles Caffin defined the term in *The Story of American Painting* (1907) as the use of limited colour scales and the delicate effects of light to create vague suggestive moods of intimacy and expressiveness. Flourishing from about 1880 to 1915 in Canada, Tonalism appeared in the landscapes of painters who grouped themselves around the Canadian Art Club in Toronto in the years 1907–15.

In his moonlight paintings, Thomson adopted this dreamy, pale-toned style of painting, though he also applied the Impressionists' goals of exploring the way the outdoor world was affected by light, its reflection, and its atmosphere. When he painted night scenes, he worked indoors in the light but went in and out until he completed the sketch. The result here is an exceptional work painted with great strength. Thomson expresses his infallible feeling for radiant light and composition as well as his skill in indicating the outline of the moon and the branches of the trees on the shoreline. The result is not so much a nocturne as a symphony.

Oil on composite wood-pulp board, 26.4 x 21.6 cm
Thomson Family Collection

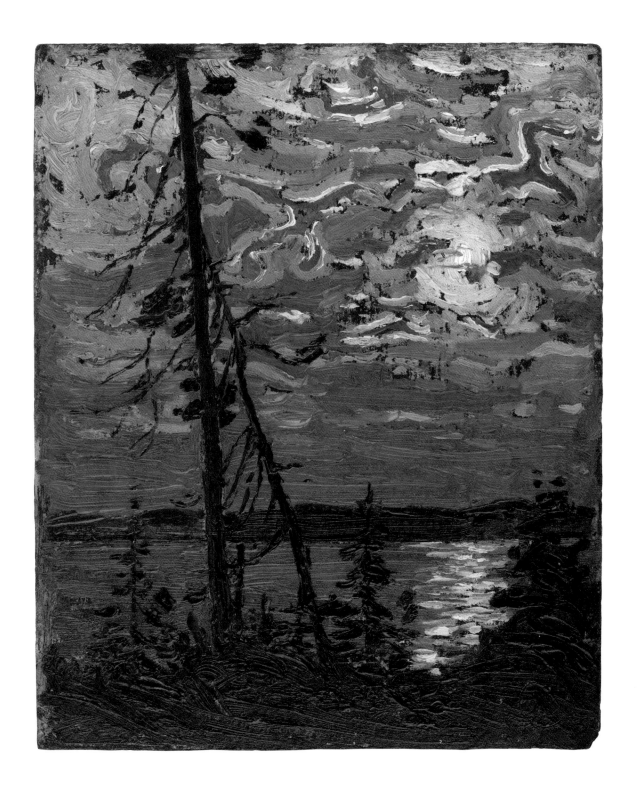

Northern Landscape

fall 1915

On the verso of *Northern Landscape* MacDonald wrote, "Not for Sale." In this sketch Thomson brilliantly revealed the shape of the hill behind a dense group of trees and bush. Every brushstroke has a double life – as description and as a means of evoking colour in a rich design. The details are intricate: pockets of white snow appear in several places amid the blaze of reds and purples, indicating the approach of winter. As a painter, Thomson understood how to use his brush to make viewers see in a fresh way something that might be considered prosaic. His ability to compress a variety of effects into a small panel makes the result seem all the more focused.

Clearly, by 1915 Thomson had made the exhilarating yet difficult discovery of his voice as an artist. He was taking ownership of his experience in nature by painting Algonquin Park in different seasons and under varying weather conditions. He worked for long periods alone, but he must have known that these sketches would provide him with a large body of motifs to draw on for major canvases once he was back in the studio in Toronto. Unfortunately he did not get the time to realize that dream, except for a small group of paintings.

Oil on wood, 21.4 x 26.7 cm
Thomson Family Collection

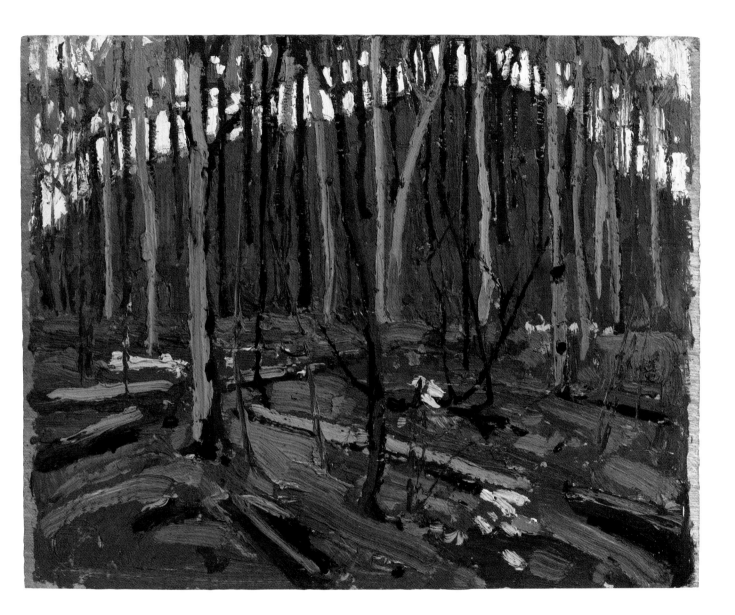

Tamarack Swamp

fall 1915

On the verso of this sketch Harris wrote, "1st Class." Like others among his favourites, this work would have interested him because of its colour and its composition. As in *Burnt Land*, which Harris owned (page 37), Thomson boldly simplified the composition and his handling of paint. The result is a powerful, almost stark work.

In the National Film Board's documentary about Tom Thomson, *West Wind*, Harris summarized Thomson's genius as a "concentrated directness that went right to the heart of whatever he was painting" and "an easy … yet inspired skill in applying paint" that drew from the colour its "maximum vitality." The painting is a concise depiction of clouds gathering in the blue sky over dark hills, which are illuminated by the brilliant colour of the tamaracks. The artist seems to have simply glided by the silent scene, perhaps coming upon it during his explorations by canoe of Algonquin Park.

Thomson created his colour effects very subtly. The touches of red that appear in the foreground seem to make the sketch come alive – to ignite the whole work. Somehow Thomson had decoded the mystery of the way pure brushwork, seen up close, coalesces at a distance into nature's forms. He may have learned this way of painting from his peers or from his training in commercial art, but his lively, radically simplified scenes suggest that he was just naturally gifted as an artist.

Oil on panel, 21.6 x 26.7 cm

Private collection

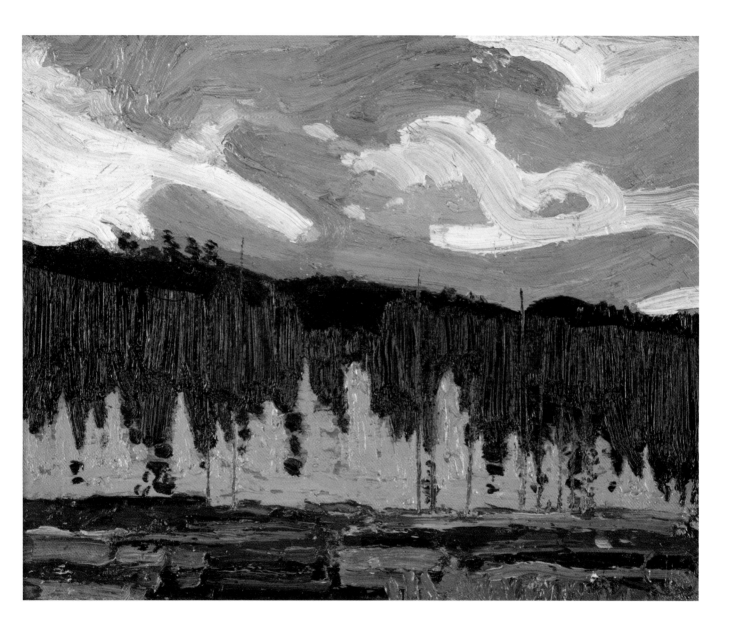

Black Spruce and Maple

fall 1915

On the back of this sketch Harris wrote, "property of Lawren Harris; Not for sale." This work illuminates Thomson's technique of placing bright colour in front of dark to intensify the richness of the effect – to draw from colour its "maximum vitality," as Harris said. There is also a teasing tension at play between Thomson's representation of the scene and the composition he created: viewers know they are looking at a strongly designed sketch, yet they react with pleasure to this broad range of fall colours so characteristic of Canadian nature.

Harris owned only four, carefully selected, works by Thomson: this painting, the canvas *Burnt Land*, and two sketches, *A Rapid* and *Autumn Birches* (pages 37, 81, and 119). This small group reflects his interest in Thomson's ability to distill his images in a way that demonstrates what he was seeing in nature. Harris also admired Thomson's skill with colour, which was sometimes contrasting but more often magically arranged to achieve convincingly his multiple purposes of design, description, and depth. Often Thomson's ravishing effects were achieved by simple contrasts and mixing or by matching within a basic palette.

Harris gave this work to the Art Gallery of Toronto (now Art Gallery of Ontario) in 1927, suggesting that, by then, he had learned all he wanted from it. He had found his own path as an artist, painting mountain compositions with a hauntingly spiritual quality.

Oil on wood panel, 21.6 x 26.7 cm
Art Gallery of Ontario, Toronto
Gift of Mr. and Mrs. Lawren S. Harris, 1927 (863)

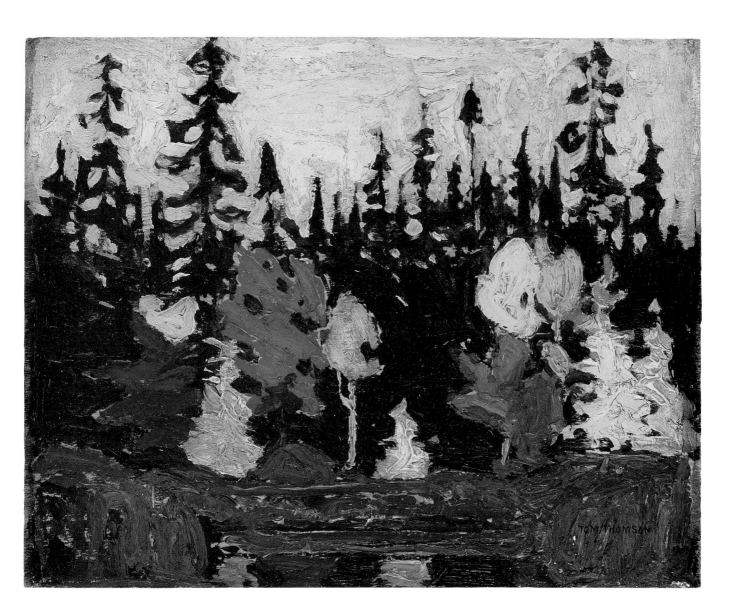

Sand Hill

fall 1915

On the back of this sketch Harris wrote, "1st class." Dr. MacCallum also wrote a long description: "Sand Hill on road to South River fall 1915 – on this day Thomson / tramped 14 miles carrying a sketch box and gun – a fox and / seven partridge which he shot that day and did this and / another sketch / James MacCallum."

Although Harris was enthusiastic about this sketch, neither he nor his collector friends purchased it from the estate, and it stayed with the artist's family for many years. Thomson painted it with great assurance – a scene of dignified simplicity that he found during his rambles in Algonquin Park. In the foreground a path curves around a stark logged hill toward a clump of birches; behind, there is a dark hill and a sliver of blue sky. The image of trees, stumps, path, hills, and sky seems animated because of the way Thomson balanced one against the other.

Thomson probably painted the sketch in the late afternoon or early evening, because the light seems to suggest "eventide." The white birches set in a thicket of bush and the dead tree and stumps, dark against the red hill, are an imaginative pairing. The prominence of the path suggests it may have been the trail Thomson would take on his way back to Canoe Lake, after he finished hunting for his supper.

Oil on wood, 21.4 x 26.7 cm
Thomson Family Collection

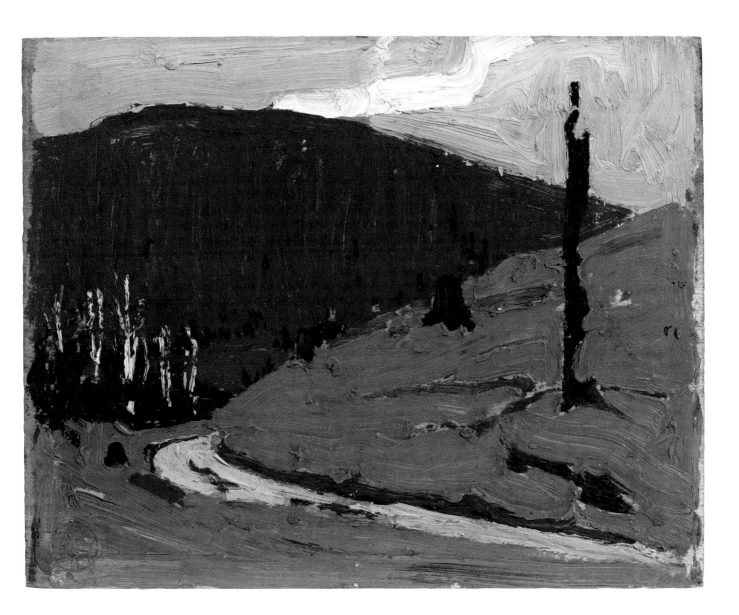

A Rapid

fall 1915

This ethereal and mysteriously beautiful sketch was one of the four works by Thomson that Harris owned. The author F.B. Housser likely saw the painting in Harris's home, because in the book he published on the Group of Seven he seems to have described the scene: a cool gnome-like spot "where wool-white water spills into miniature canyons."[9]

Thomson also seems to have held the work in high regard, because it is one of few pieces on the back of which he wrote the title and his name. Another inscription, "Not For Sale," was likely added by Harris, though today only "For Sale" remains, the "Not" having vanished with time. Later these words were crossed out, again probably by Harris after he purchased the sketch.

Eric Brown, the director of the National Gallery of Canada, wrote a letter to MacDonald on June 28, 1916, about an article he was writing on the Algonquin Park School for the prestigious magazine *The Studio*. On the bottom of this letter, Thomson wrote a note to MacDonald that suggests Harris may even have acquired this panel during the artist's life: "If I were sending any sketches my choice would be one … Lawren has of some rapids."[10] Although this sketch appears monumental at first, Thomson also imbued the scene with considerable delicacy.

When Harris painted in the Agawa Canyon in Algoma in 1918, MacDonald remarked that his sprightly sketches showed his delight in the rivers, streams, and springs that ran through the ravines. Harris's sketch *Waterfall, Algoma Canyon, Algoma* (Thomson Collection, Art Gallery of Ontario) recalls this painting by Thomson in its dark background and touches of yellow and, to some extent, in the central motif of a waterfall. Harris, however, may have been quite unconscious of the resemblance.

Oil on panel, 21.6 x 26.7 cm
Art Gallery of Ontario, Toronto
Gift of Mr. and Mrs. Lawren S. Harris, 1927 (864)

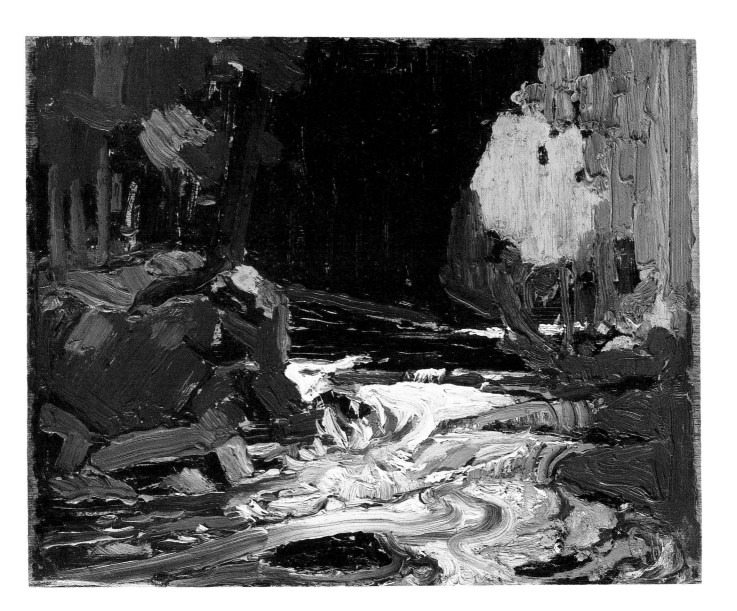

Sketch for "Autumn's Garland"

fall 1915

During the fall of 1915 Thomson often painted with a surprisingly high-keyed palette, as he experimented boldly with colour and different ways of handling paint. In this sketch Thomson portrayed a richly coloured section of forest in powerfully condensed areas of colour, but he delicately delineated the vines of red leaves that flow through the work.

As he often did, he added the sky last, and patches of blue overlie the background foliage in various places.

When he returned to his studio in Toronto for the winter that year, Thomson drew on this sketch as he developed the canvas *Autumn's Garland*, one of the treasures of the National Gallery of Canada. He increased the feeling of space by inserting rocks for the garland of red leaves to climb over and adding a curtain of foliage in the background and more sky, while toning down the colour. Although he retained the sapling of the sketch, he made it more curvaceous.

Some commentators believe that this sketch may have been painted from memory in Thomson's studio, but certain details, such as the rock on the right and the firm feeling of depth, point to Thomson's direct observation of nature. Others suggest that this sketch may have been among those Jackson recalled as "experimental" – the works Thomson kept as references for developing larger canvases. Although we believe this group existed, we do not know which sketches were included or how the group changed over time as Thomson developed his vision of what art could be.

This sketch was owned by Thomson's brother George and later by the distinguished collector H.S. Southam. When Ken Thomson acquired it, he counted it as a favourite.

Autumn's Garland, winter 1915–16, oil on canvas, 122.5 x 132.2 cm, National Gallery of Canada, Ottawa, purchase, 1918 (1520)

Oil on composite wood-pulp board, 21.6 x 26.7 cm
Thomson Family Collection

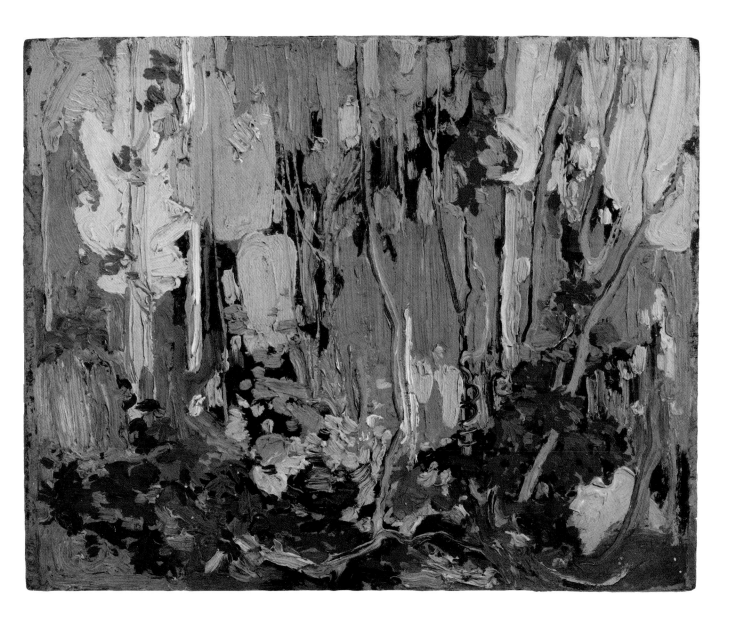

Birches and Cedars (Fall)

fall 1915

Harris most likely selected this work because of its tight focus, rich colour, and innovative handling of form. The brushwork is bold, notional, and almost abstract. Paint is applied in quick patches, building up texture. In this sketch, as in so many others, Thomson was engrossed in the challenge of looking at the scene he had chosen and painting it, probably from a canoe, never wavering from his goal of translating his perception of Algonquin Park into art.

Two other sketches Thomson painted that fall, *Red and Gold* (private collection) and *Autumn Foliage* (Art Gallery of Ontario), are of hillsides on which the trees display a full range of autumn colour. In *Birches and Cedars (Fall)*, Thomson looked closely at the shoreline and the colours of the trees he saw there. This sketch is the most broadly and adventurously painted of the three.

Harris reserved all three for himself, his friends, or major institutions. He wrote "1st class" on the back of this one, underlining the numeral. On *Red and Gold* he wrote, "Reserved Studio Bldg. Lawren Harris," and on *Autumn Foliage*, "Reserved Studio Bldg." *Birches and Cedars (Fall)* seems to have been his favourite, the one he rated most highly.

This is surely one of the most beautiful of the many impressive paintings Thomson created of Algonquin Park. In it he was clearly using the new freedom he had discovered during his camping trip through the park the previous fall with Jackson, Lismer, and Varley as a way to invigorate his work. The sketch has great spirit and the sure touch of an artist who is expanding and deepening his repertory. Its brevity and impact reveal Thomson's sharp eye for imagery and his ability to convey what he saw.

Oil on wood, 21.6 x 26.7 cm
Thomson Family Collection

Black Spruce in Autumn

fall 1915

In his autobiography *One Man's Obsession*, Robert McMichael describes the acquisition of this beautiful work from Thomson's sister Margaret. "The stunning landscape embodied everything we admired most in Tom Thomson's work," he wrote. "Soaring dark silhouettes of ragged spruce stand as gateposts on jutting headlands which form a narrows in the long lake. Beyond, like a vast stage bathed in full light, stretches a densely forested autumn hillside ... The ominous approaching wall of cloud has its own swirling energy in paint, trowelled with a broad, paint-loaded brush onto the board."

Algonquin Park brought out the best in Thomson's art: assurance, effortless economy, and the ability to convey a strong sense of three-dimensional space.

Oil on laminated paper or composite wood-pulp board, 21.7 x 26.8 cm
McMichael Canadian Art Collection, Kleinburg, Ontario
Gift of Margaret Thomson Tweedale, 1966 (1966.14)

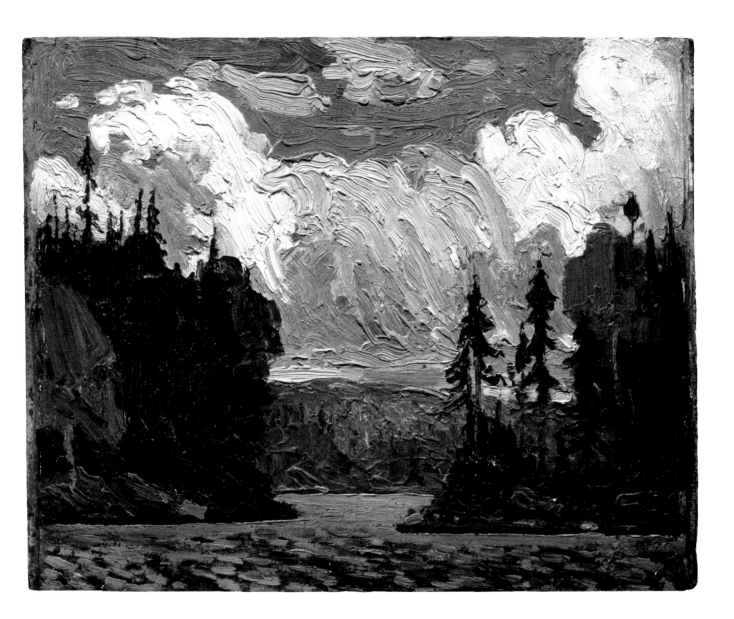

First Snow, Canoe Lake

fall 1915

First Snow, Canoe Lake is a painting that perfectly renders the beauty of Canadian nature at the magical time when winter makes its first appearance. The view toward the lake and the late afternoon light create a subtle feeling of spaciousness. The glowing pink and rose undertones of this time of day underscore the fading autumn colour. Thomson sketched this scene just as he was beginning to exhibit a new decisiveness in his brushwork and handling of paint, and it evokes the full range of his sensibility, from brusque to delicate. For a meditative viewer, this sketch quickly becomes a harmonious blend of textures and rhythms – a hymn to Canada.

The painting came from the Thomson estate. Elizabeth Thomson Harkness, Thomson's eldest sister, listed it as number 31 in her records. On the back there is a torn label with the words "First Snow / 10 Not For [Sale]…" ("10" is circled), written by Lawren Harris. Dr. MacCallum wrote in graphite, "First Snow fall 1915" ("1915" is underlined) and "Canoe Lake / Back of Frasers." Thomson painted it, then, in one of his favourite locations, Canoe Lake in Algonquin Park, behind Mowat Lodge, the boarding house run by his friends Shannon and Annie Fraser where he often stayed during the cooler months.

The sketch was included in a Thomson show at the Arts Club of Montreal in 1919. Around 1937 Mellors Galleries in Toronto purchased it from the estate as one of a group, and it was then bought by a private collector in Montreal. It remained in that family collection for the next seven decades.

Oil on wood, 20.3 x 27.0 cm
Private collection

Spring Ice

winter 1915–16

On his return from Algonquin Park to the studio in Toronto in the late autumn, Thomson used a few of the sketches he had made from nature to develop larger canvases. The sketch for this canvas offered him a compositional motif – the breakup of the ice in spring – but he enriched the coloration and made many other changes for a more decorative effect. He introduced greater stylization to the forms of the trees and clouds, for instance, and created a larger and more open imaginary space for his picture. The main excitement in this larger work, however, lies in Thomson's play with the basic elements of painting: the wide range of colours, luminous light, and the application of the paint in textured strokes. It is one of the few instances where the larger painting is generally considered superior to the quick sketch on which Thomson based it.

Thomson exhibited the painting at the *Ontario Society of Artists Forty-Fourth Annual Exhibition* from March to April 1916. Eric Brown, the director of the National Gallery of Canada, recognized that the painting represented a new spirit in Canadian art and encouraged the gallery to purchase it. The price was $300.

The Opening of the Rivers: Sketch for "Spring Ice," spring 1915, oil on composite wood-pulp board, 21.6 x 26.7 cm, National Gallery of Canada, Ottawa, bequest of Dr. J.M. MacCallum, Toronto, 1944 (4662)

Oil on canvas, 72.0 x 102.3 cm
National Gallery of Canada, Ottawa
Purchase, 1916 (1195)

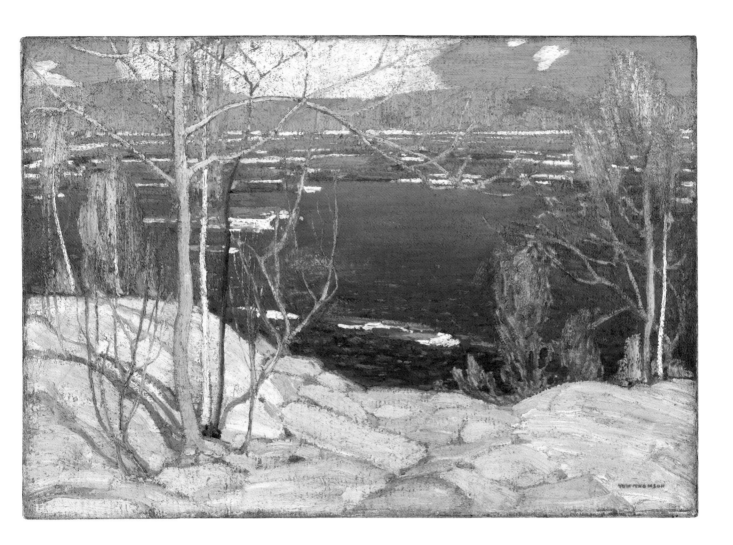

Sketch for "Evening, Early Spring"

spring 1916

This sketch served as the basis for the canvas *Evening, Early Spring* (private collection). Although seemingly simple, it has a strong design. Clearly Thomson regarded it as important – it is one of the few panels he signed on the recto.

This painting was once owned by J.J. (John James) Vaughan of Toronto, who began working for the T. Eaton Company in 1903 and became an adviser and friend to John Craig Eaton; by 1933 Vaughan was vice-president of the company. His house and extensive grounds on Bayview Avenue in Toronto are today part of the estate belonging to Sunnybrook Hospital.

Vaughan was one of the founders of the Art Gallery of Ontario (then the Art Museum of Toronto) and a knowledgeable collector of Canadian and European art. He owned three of Thomson's sketches and would have chosen only the finest for himself. In October 1959 Vaughan lent some seventy-five Canadian paintings to the *Exhibition of Loans from Private Toronto Collections* at the gallery. According to the catalogue, three works by Thomson were among them: "Winter Woods at Twilight," "Winter at Algonquin Park," and "Pine and Spruce by Lake." Unfortunately no one noticed these titles on the backs of the works, and they have been retitled over time. This sketch was likely the one titled "Winter at Algonquin Park" because, on the verso, someone has written, "Algonquin Park."

The absence of any other markings on the back of this work is curious. There is no indication of who owned it before Vaughan or how it came into his hands. The verso was covered with grey paint, likely by Thomson himself. The art dealer Blair Laing owned it after Vaughan, and, beside the words "Algonquin Park," there is a label from Laing Galleries in Toronto.

Oil on wood panel, 27.1 x 22.1 cm
Thomson Family Collection

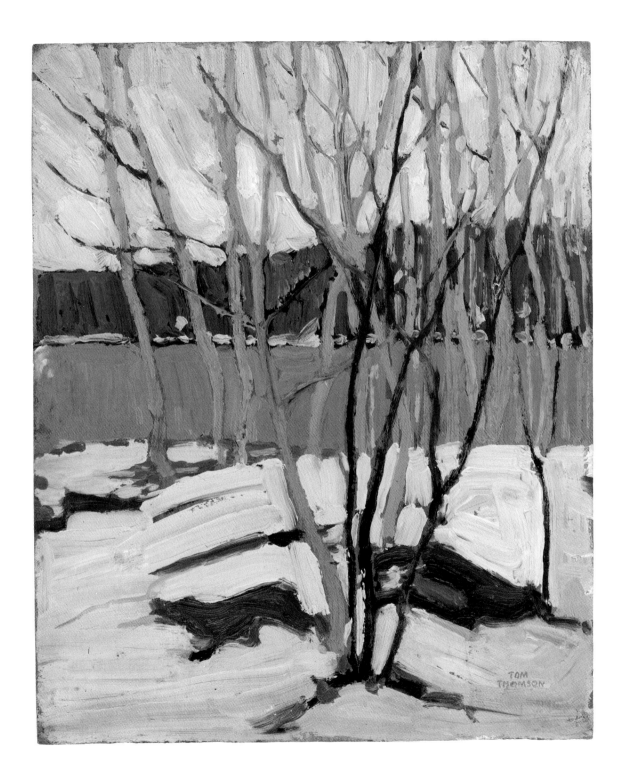

Spring, Algonquin Park

spring 1916

On the verso of this sketch MacDonald wrote, "reserved / Studio Bldg." The energy and compression in this painting were no doubt the qualities that appealed to him and Harris and persuaded them to put it aside for themselves or their friends.

Thomson painted a number of snow studies during the spring of 1916 in Algonquin Park. In this painting he firmly recorded that the snow had receded on the hillsides – there is the promise of real spring in the air. An impressive group of cumulus clouds seems to float in the blue sky above. Thomson's eagerness to paint the beauty of the scene before him clearly comes through in this work. In it he captured the essential freshness and beauty of pristine nature.

When Thomson looked at the shapes and textures in nature in Algonquin Park, he was often working with a confined space. He took a close-up view, with only a limited amount of depth. He gave his work a feeling of space and distance through a variety of compositional devices, such as a lake or a sky glimpsed behind a screen of foliage, or the shadow of a tree in the viewer's space falling in the foreground of the painting. Here he emphasized the way the dead trees and rocks lead to the distant broad, flat masses of land. The clouds too seem to expand and hover – a difficult feat in painting.

Oil on wood panel, 21.3 x 26.7 cm
Agnes Etherington Art Centre, Queen's University, Kingston, Ontario
Presented by the Queen's Art Foundation, 1941 (00-126)

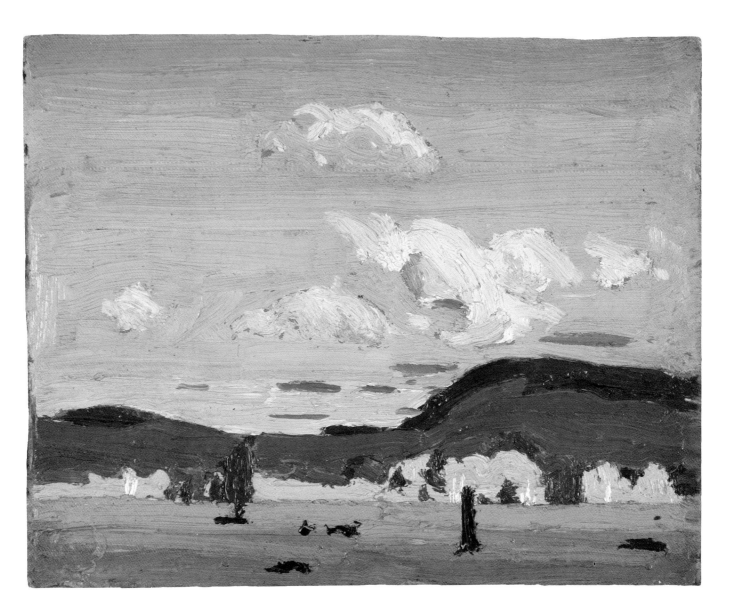

The Poacher

spring 1916

Thomson rarely included figures in his paintings. When he did so, he seems to have been prompted by the subject's proximity to him. In the spring of 1915, for instance, he painted a portrait of his friend Shannon Fraser, seated, pipe in mouth, and sporting a red jacket, blue shirt, and pink tie. In this sketch of a poacher, Thomson again sought to suggest a particular person and carefully recorded details of his outfit, from the hat that partially hides the man's face to the hunting vest and blue shirt. He is seated comfortably before a grill over hot coals and is drying something – likely venison cut into strips or whatever he has poached.

As with other sketches from 1916, this painting is characterized by clarity of composition and rich colour. The green foliage indicates the time as late spring. It was painted on a wood panel, and the few patches of wood that are visible lend it an airy feeling. The fluid, energetic handling of paint – apparent in the thin, nervous lines used to indicate saplings, branches, and shadows – is also characteristic of Thomson's work that spring.

The unusual, somewhat mysterious subject and the elegant handling help to explain why Ken Thomson especially valued this painting among the many works by Tom Thomson he owned.

Oil on wood panel, 21.5 x 26.8 cm
Thomson Family Collection

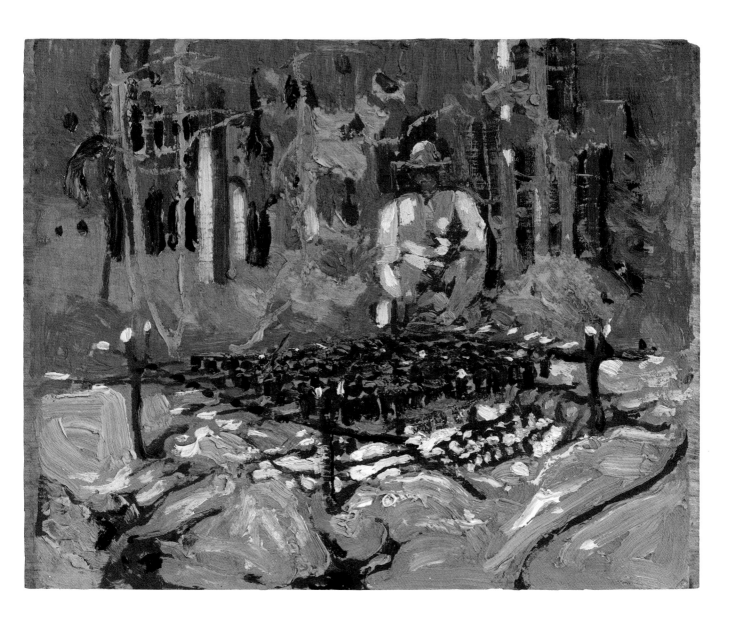

Early Spring in Cauchon Lake

spring 1916

On the verso Lawren Harris wrote, "1st class," and a few more descriptive lines: "Early Spring. / Background is a high hill covered / with budding hardwood & a few spruce." He was able to add these details about the scene because, in April or early May 1916, he, his cousin Chester Harris, and Dr. MacCallum had journeyed to Algonquin Park to join Thomson at Cauchon Lake. Obviously the clarity and rigour of this quiet sketch evoked many memories in Harris.

Here Thomson revealed his complete command of composition and colour. In bold, economical lines he has captured the structure of the hill across the lake, its slopes harbouring the last patches of winter snow amid the new season's growth. Its mass forms a strong contrast to the spindly trees on their outcrop of rock in the foreground. In between, the milky grey-greens of the lake reflect that brief moment as the final vestiges of ice melt in the water.

The trip may have also been significant for Thomson's large canvas *The West Wind*, which he painted the following winter after his return from the park (page 129). Dr. MacCallum recalled in a letter of May 14, 1937, to Miss A.L. Beatty at the Art Gallery of Toronto that Thomson painted his sketch for that painting while he was on this shared trip to Cauchon Lake.[11]

Oil on wood, 21.2 x 26.7 cm
McMichael Canadian Art Collection, Kleinburg, Ontario
Anonymous donor, 1972 (1972.4)

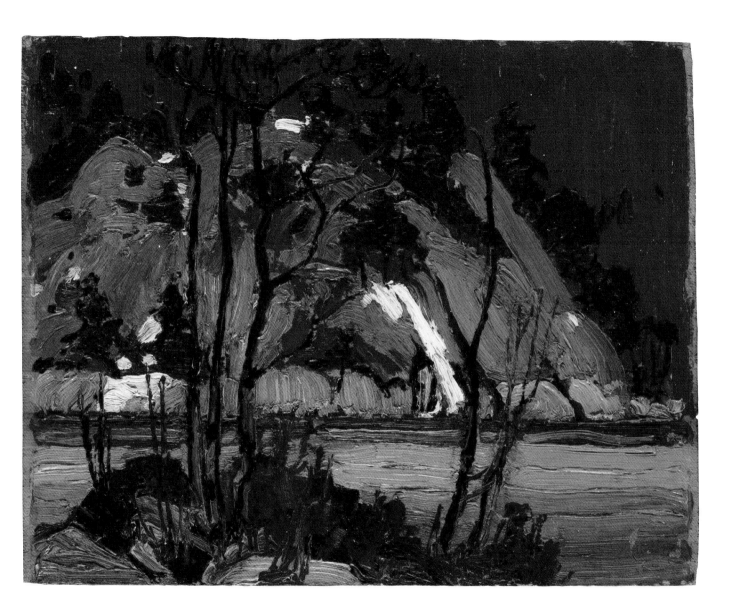

Logging, Spring, Algonquin Park

spring 1916

Late in May 1916 Thomson took a job as a fire ranger and, with his friend Ed Godin, was stationed at Achray on Grand Lake. In August they made a canoe trip down the south branch of the Petawawa River (now the Barron) and up the north branch of Lake Traverse. Thomson likely painted this sketch while he followed the drives of the Booth Lumber Company on the river.

Most of his sketches that season were painted on wood panels, and Thomson left patches of the wood visible through the paint to give the scene a sense of open space. His drawing of the loggers and their horse-drawn loads is energetic and elegant, with a strong sense of three-dimensional form. The coloration – which ranges from the pinks, grey, and blues of the snow to orange and black – is especially beautiful. Thomson introduced an adventurous note to his composition by using a cut-off view in the foreground.

Thomson painted another sketch, *Autumn Hillside*, on the back of this one – and the panel has not been divided. The colours in *Autumn Hillside* are those of the autumn season, so it was painted some months after the logging scene. That fall Thomson painted several two-sided panels. Perhaps he was running short of materials and wished to make his panels last as long as possible – or perhaps he did not have the money to buy more.

Verso sketch:
Autumn Hillside, fall 1916,
oil on wood panel,
22.0 x 27.1 cm,
private collection

Oil on wood panel, 22.0 x 27.1 cm
Private collection

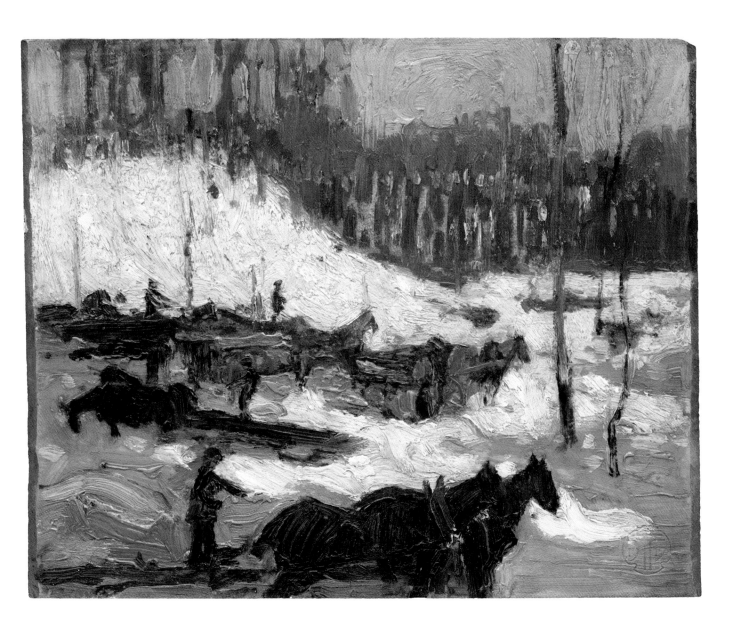

Sun in the Bush

spring 1916

On the verso of this work MacDonald or Harris wrote, "reserved / Studio Bldg." In addition, the initials "SB" were applied in ink with a brush.

This painting of snow in Algonquin Park seems to distill the rosy light of early morning. The scene is compressed into an intricately designed sketch constructed from a variety of large blocks of colour playing off against each other: pink, where light falls on the snow; blue, in the shadows; and browns and greens, for the trees, bushes, and patches of earth where the snow has melted. The painting may be read as a symbol of the season. Thomson drew some of his ideas about composition from his work in commercial art – the cut-off view he applied to the tops of trees and the sides of the scene, the strong contours, and his skilful way of suggesting form.

This painting was owned by the highly respected Canadian medical reformer and educator Dr. Duncan A. Graham (1882–1974), who headed the Department of Medicine at the University of Toronto from 1919 to 1947 and was physician-in-chief at the Toronto General Hospital. He was probably introduced to Thomson's work through his colleague Dr. MacCallum. In 1961 Dr. Graham gave this sketch to his daughter, Enid Mary Lewis.

Oil on wood panel, 21.5 x 27.0 cm
Thomson Family Collection

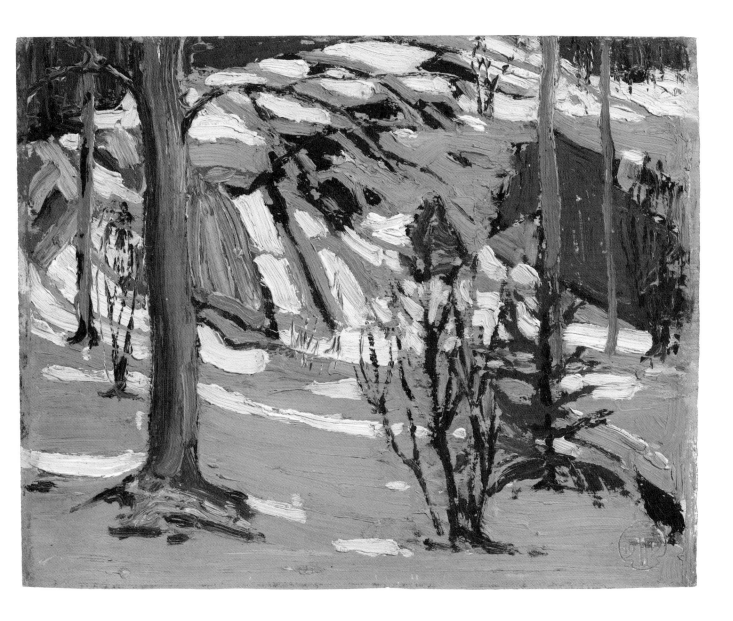

The Dead Pine

fall 1916

On the back of this sketch MacDonald or Harris wrote, "Reserved Studio Bldg." The inscription continues, "for wc Laidlaw" and "for RA Laidlaw." These two brothers, Walter and Robert Laidlaw, were industrialists and financiers as well as art collectors. In due course the initials "wcL" were circled and "RAL" crossed out, and the work went into the collection of Walter Laidlaw. It appeared in an exhibition in 1959 and was credited to his collection, so we know he kept it for many years.

On one occasion, Thomson told Mark Robinson, a ranger in Algonquin Park, "I want to get a pine with old branches coming out … the ugliest looking old thing."[12] He found it, and he gave the dead pine in this sketch a wiry animated presence, as though it were still alive. Thomson not only made trees into a remarkable visual spectacle in his works but also often used them to provide a sense of scale and measurement. He recorded trees during their whole lifespan, from earliest growth, through all seasons, and to the interesting shapes they made after they died. One of his friends, Ernest Freure, recalled the time he told Thomson about his plans to clean up the dead trees and logs on his island in Georgian Bay. Thomson replied, "No, don't do that – they are beautiful."[13]

During the summer and autumn of 1916 the subject of trees was much on Thomson's mind. He pursued it with enthusiasm and, in his sketches, became something of a collector of the different species that exist in Algonquin Park. Lying in the transitional zone between the northern boreal forest and the southern Great Lakes deciduous forest, the park is a rich area for trees and reflects an ever-changing balance between different varieties.

Oil on wood panel, 26.7 x 21.4 cm
Thomson Family Collection

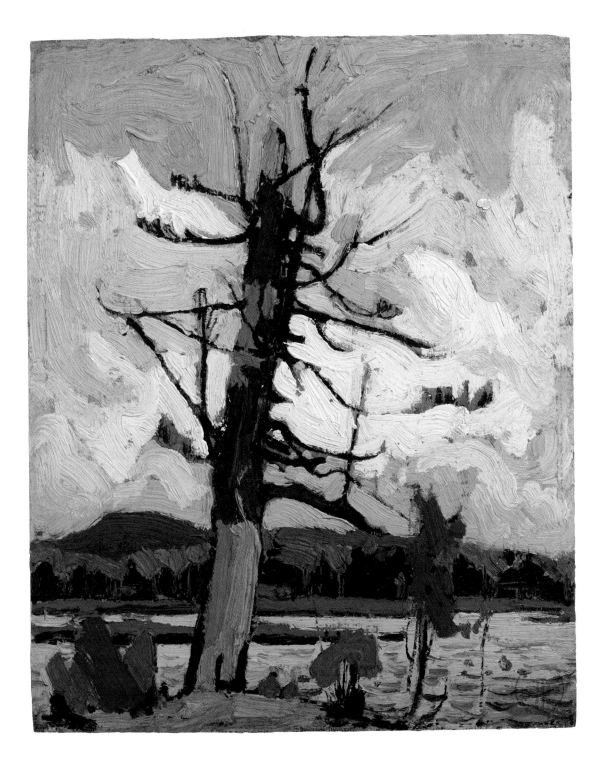

Autumn, Petawawa

fall 1916

In August and September 1916 Thomson travelled by canoe down the south branch of the Petawawa River (now the Barron) and up the north branch of Lake Traverse. As his friend Ed Godin, who accompanied him, later recalled, "Tom sketched the Capes on the South Branch."[14]

Thomson probably painted this work a few weeks into the trip, perhaps in the early morning before they set out in the canoe that day. He was clearly intrigued by the rock walls and recorded them firmly, using close-up views and sophisticated colour – festive pinks, corals, and greens. The red leaves in the foreground, a homage to the autumn season, present an additional vivid touch. In cutting off the top of the foreground tree, Thomson made viewers feel that they are standing nearby.

The artist Fred S. Haines, principal of the Ontario College of Art after J.E.H. MacDonald died in 1932, once owned this work. Before his appointment there, he had been the curator of the Art Gallery of Toronto (now Art Gallery of Ontario) for five years, and he would have heard about Thomson's importance from A.Y. Jackson and Lawren Harris in particular as they arranged for the gallery to receive its first Thomson paintings. In its bold, economical lines and strong patches of colour, *Autumn, Petawawa* is in the forefront of Modernism.

Oil on wood, 21.0 x 26.0 cm
Thomson Family Collection

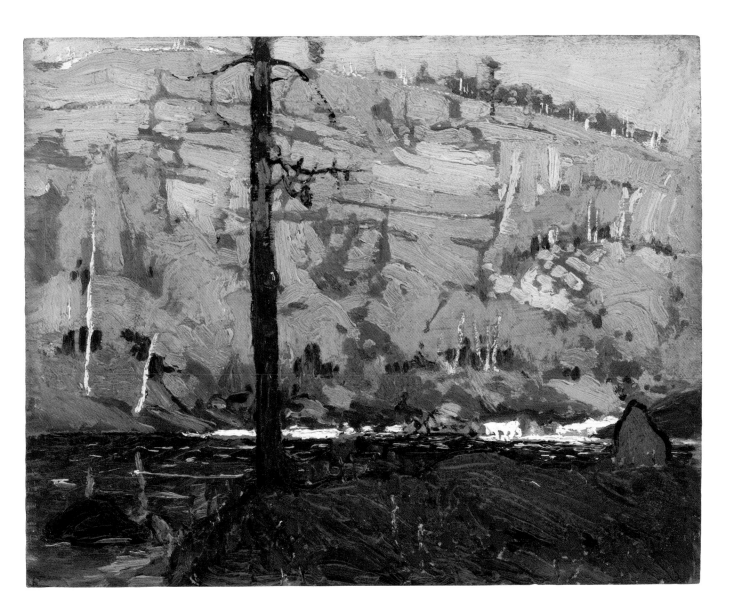

Petawawa Gorges

summer or fall 1916

On the back of this sketch, half hidden by an Art Gallery of Ontario label, can be found the first word of the phrase "1st class," which Harris wrote on the backs of the works he considered the most important in Thomson's estate. MacDonald also wrote on the back (inside a section squared off in graphite), "Tom considered this sketch / his best & intended [making?] / it a large picture / J.MacD."

Thomson probably saw in this thinly brushed sketch a way of creating, later in his studio, a decorative spatial arrangement in a major canvas. He would have found several elements in it exciting – the nervous energy of the trees and the way the island in the middle ground lies in the dark while sunlight hits the distant hills. The shadow cast by the island in the foreground suggests that it is early morning – Thomson was up with the dawn, painting this sketch before he and his friend Ed Godin broke camp to continue their canoe trip. In a way, the sketch is a testimonial to an unknown land glimpsed for a moment by a traveller.

If Thomson had lived to paint the work he planned, he no doubt would have strengthened the colouring he used in the sketch and clarified the composition – just as he did with other canvases he developed from sketches painted in nature.

Oil on wood panel, 21.5 x 26.8 cm
Art Gallery of Ontario, Toronto
Gift of Miss Hilda Harkness, Ottawa, 1983 (84/40)

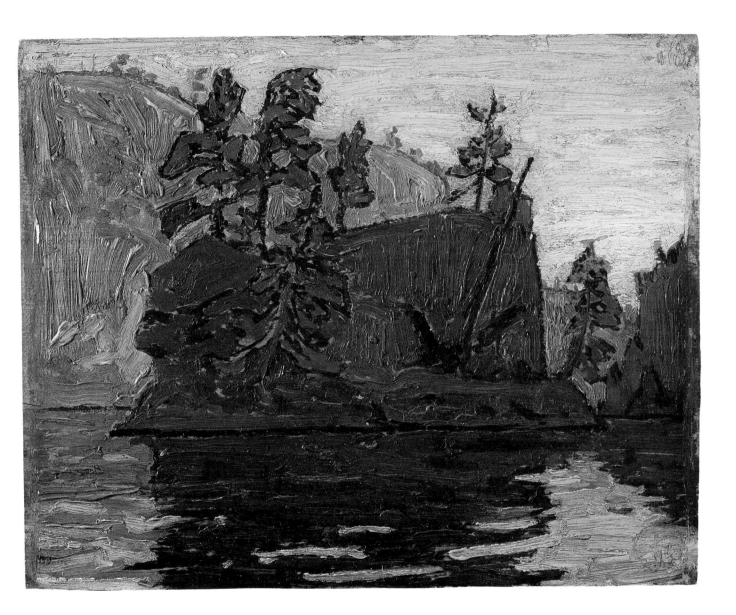

Petawawa Gorges

fall 1916

Some of Thomson's Petawawa Gorges compositions are spare and emblematic, but this one, with its distinctive structure and colours ranging from gold and orange to a range of blues, reveals what the place meant for him – it was a "great" place for sketching, as Thomson wrote in a note to MacDonald on the bottom of a letter from Eric Brown, the director of the National Gallery of Canada, to MacDonald on June 28, 1916.[15] Clearly the pieces Thomson painted in the gorges are memorials to a unique site. He picked up visual elements of the landscape and mixed and arranged them depending on the time of day and qualities of light, like variations on musical themes.

In this work the shadows on the high rocky hillsides indicate that Thomson and his friend Ed Godin had stopped canoeing for the day and set up their camp. The time is early evening. What we see is a moment of luminous beauty enhanced by the way Thomson used strokes of paint to emphasize the imposing structure of the hills and the engaging colours of trees, vegetation, sunlight, and shadow. As it sets, the sun touches the hill in the distance with orange – a note of brilliant energy that is both intimate and direct and, ultimately, poetic. No wonder Harris or MacDonald wrote "Not for Sale" on the back.

The sketch came from Alan M. Cameron of Sudbury, along with *Burnt Land*, today also in the McMichael Collection (page 47). Robert McMichael had persuaded his friend Major Fred Tilston to donate $40,000 for the purchase of this sketch.

Oil on wood, 21.4 x 26.5 cm
McMichael Canadian Art Collection, Kleinburg, Ontario
Purchase with funds donated by Major F.A. Tilston, VC, Toronto, 1981 (1981.9.2)

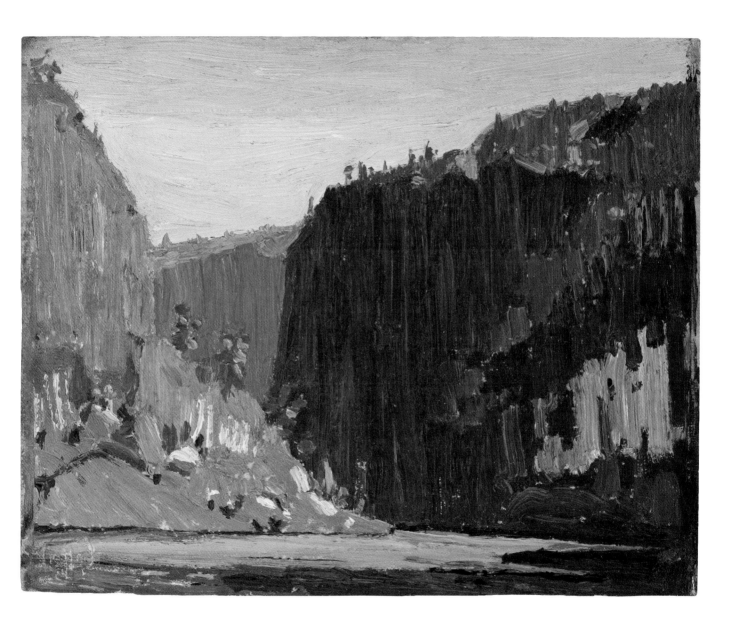

Autumn, Algonquin Park

fall 1916

At first glance, Thomson seems to have painted in this panel a subject he often recorded – the view from a shoreline in Algonquin Park, looking across a lake to a narrow inlet, distant hills, and the sky. On closer inspection, the austere simplicity of Thomson's creation, its firm design, and beautiful colour reveal the exceptional quality of this painting. Viewers are reminded of the kind of work Thomson might have made had he not died just four years into his prime as an artist.

In his sketches Thomson revelled in creating a structure with a distinct topography and, within that boundary, having the freedom to define the composition and handle his paint. He liked to look closely at the scene before him and absorb his impressions of it before he set to work. He had exceptional sensitivity to nuances of colour and the myriad ways of applying the paint with his brush. In this sketch he united parallel horizontal fields composed of water, distant shoreline, rock, forest, and sky through the use of vertical elements composed of trees, branches, and bushes. He described them all with firm brushstrokes and in rich reds and yellows. In the distant tree line, he almost carved the shapes out with the handle of the brush. The work has an air-filled ambience that conveys the breezy quality of the fall weather.

It is no wonder that, on the verso of the panel, Harris wrote, "reserved / Studio Bldg.," and enclosed the words in a box.

Oil on wood panel, 21.6 x 26.7 cm
Private collection

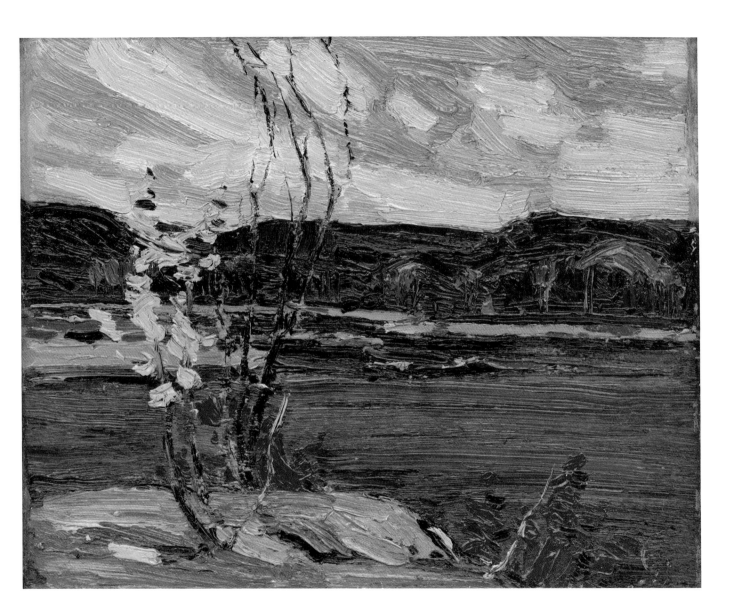

Wild Geese: Sketch for "Chill November"

fall 1916

Thomson was interested in the naturalist's world in Canada. On several occasions he painted the migrations of wild geese or ducks in the autumn. In this sketch the delicate forms of the birds fly convincingly in the expanse of overcast sky, above snowbound hills and the quiet waters of a lake. It is a subtle sketch and, with its luminous, jewel-like tones, shows Thomson at the height of his powers.

He deliberately recorded the flight in disorderly array to indicate the changeability of its arrangement over time. Back in the studio in Toronto, he used this sketch to develop a major canvas, *Chill November*, today in the collection of Gallery Lambton, Sarnia.

In his book on Tom Thomson, Harold Town discussed these two works, writing that in both the geese are unconvincing because they are "broken beads, an abstract caprice in a realistic setting." He continued, "Though a challenge bravely pursued, these works represent Tom taking a whack at the impossible."[16]

Lawren Harris would have disagreed with Town. He wrote on the back of this sketch, "1st class." Likely it was he who advised his friend Fred Housser, the author of the first book on the Group of Seven, *A Canadian Art Movement*, to purchase the painting.

Oil on wood panel, 21.4 x 26.7 cm
Museum London, London, Ontario
F.B. Housser Memorial Collection, 1945 (45.A.24)

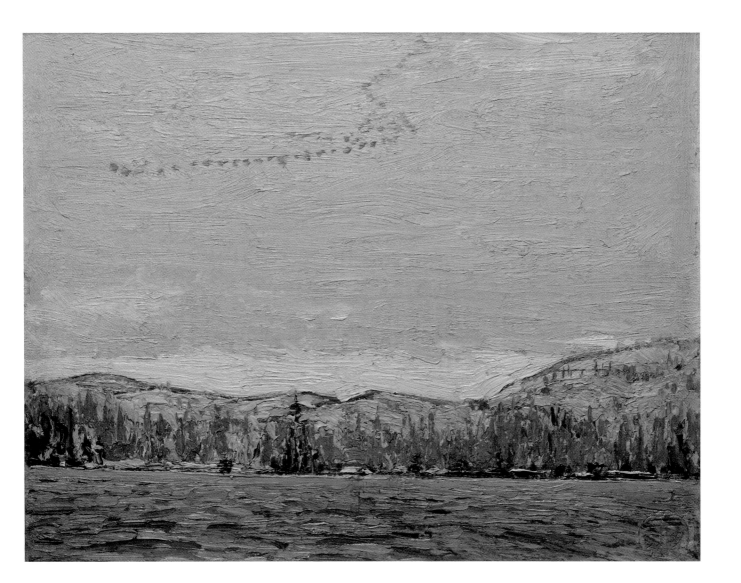

Spruce and Tamarack

fall 1916

This sketch is a superb example of Thomson's way of contemplating nature and recording it in rich colour and rhythmic pattern. As with other works from 1916, it illustrates how Thomson was able to create a lively interplay of board and pigment by revealing the wood of the panel through the paint. His composition at first looks simple – patching in delicate indications of water against a red and brown ground; then setting tall dead trees and coral, gold, and tan tamaracks against a darker background of green and black spruce; and finally, positioning the whole against a sky that changes in colour from lavender to cerulean. The total effect, however, offers an impressive new turn on recording nature in the North.

The mandate Thomson set for himself, as did his artist friends, was to "make it new." They wanted to analyze nature for its structure and produce an art concerned with space. They also wished to explore the use of colour, boldly, to create a more expressive and individual kind of art. This painting, even with its quiet, sequestered feeling, fits that bill.

Spruce and Tamarack was once owned by Walter C. Laidlaw. He had been a student at Upper Canada College, class of 1891, and in 1947 he donated this sketch to the school. Ken Thomson had long admired the work, and in 2005 he was able to buy it for his collection.

Oil on wood, 21.1 x 26.3 cm
Thomson Family Collection

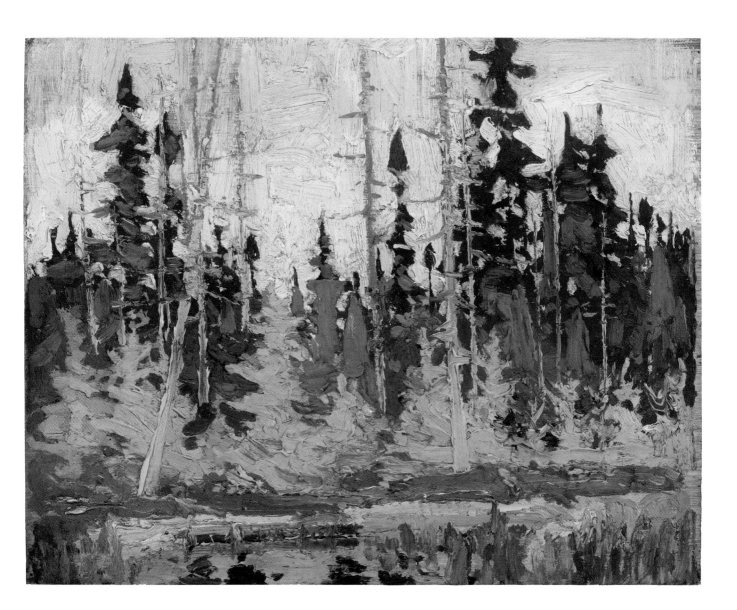

Autumn Birches

fall 1916

Lawren Harris owned this record of the autumn season in Algonquin Park. It relates stylistically to Thomson's work of 1915 and 1916, which often portrayed a scene with a screen of trees in the foreground and a stream or lake in the distance. In this sketch Thomson boldly summarized the view, recording the birch trees but cutting them off, so that they seem to extend beyond the painting and into the space of the viewer – a stylistic device he would have known from his work in commercial art and photography. The land itself also appears to extend beyond the space of the sketch.

Thomson gave the imagery an assertive presence by applying the paint thickly, as in the red foliage of the tree close to the centre of the sketch. Using a rich range of golds, oranges, and reds, and setting them off with brown and black, he produced a three-dimensional scene that conveys the quiet light of a fall day. In this composition the viewer's eye seems to move from the left foreground into the background along a line of trees and beyond, into the distant waters of the lake, then the shore, and finally the sky. In this way, Thomson transformed his view of nature into a sensuous whole.

Canada Post issued a pair of twelve-cent commemorative stamps on June 26, 1977, to honour the centennial of Tom Thomson's birth. This sketch and *April in Algonquin Park* (Tom Thomson Art Gallery) were selected as the images. They quickly became one of the most popular sets of stamps ever produced in Canada.

Oil on wood panel, 21.7 x 26.7 cm
Art Gallery of Ontario, Toronto
Gift of Mr. and Mrs. Lawren S. Harris, 1927 (862)

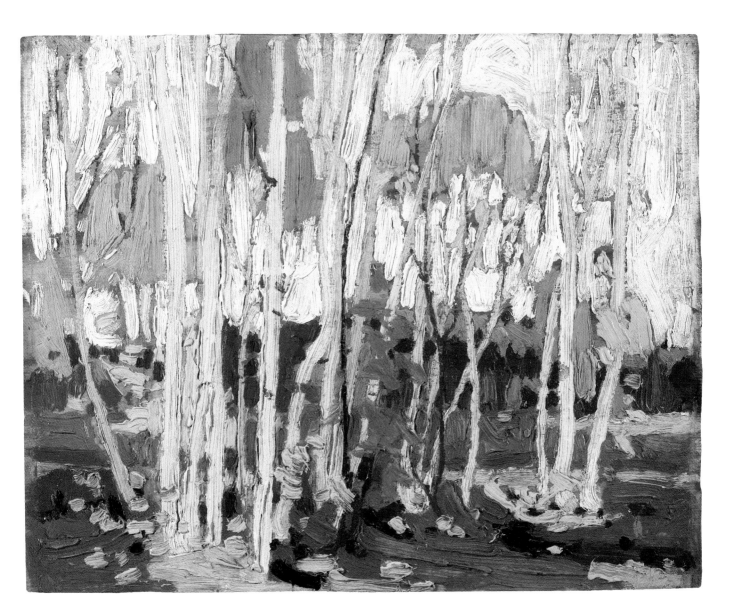

Blueberry Bushes, October

fall 1916

Harris wrote on the verso, "1st class," but later crossed the words out. Dr. MacCallum added, "Blueberry Bushes Oct 1915-JM." MacCallum was sometimes wrong with his dating, and today experts agree that most of Thomson's sketches on wood panel were painted in 1916, rather than 1915 – hence the dating here. This sketch is excitingly bold in its loose painting and strong composition, with the contrasting diagonals of the bent tree and the shape of the hillside. Perhaps, though, it did not fit with Harris's ideas about Thomson at the time. He and MacDonald saw in their protégé an artist who could serve as their guide to understanding the unique properties of the landscape and the weathers of the North. With its basic simplifications, *Blueberry Bushes* may have looked too roughly blocked in. Perhaps it would have appealed more to Harris later as he developed into an abstract artist himself.

As in *Black Spruce and Maple* (page 77), in this sketch Thomson set crimson red against a dark background to enhance the richness of the colour. He executed the shapes of the rocks and earth, foliage and trees with exceptional vigour in broad strokes of cream, brown, black, and green. He obviously painted in a burst of inspiration; the result is a hot flash of composition throbbing with energy and colour, galvanized and made one by his design intelligence. Viewers almost watch Thomson at work as he makes an abbreviated record of something that caught his eye in the midst of a still forest – a hillside of blueberry bushes turning bright red in the autumn.

Oil on wood panel, 22.0 x 27.0 cm
Thomson Family Collection

Winter Thaw in the Woods

fall 1916

William J. Ard, the owner of the general store in South River where Tom Thomson bought his supplies, acquired this sketch for $25. J.W. Beatty, one of Thomson's artist friends and another tenant in the Studio Building, seems to have arranged the deal. Had the work not been sold during Thomson's lifetime, Harris or MacDonald would surely have selected it. With its succinct but lavish paint handling, forceful rhythm of interlocking shapes, and telling revelation of weather, it is one of the artist's most beautiful and evocative paintings. The handling of colour here is inspired – Thomson crisply evoked irregular areas of soil in patches of Indian red, set off with vermilion, dark green, and black, so that they show with clarity through the crusty white snow.

Truman Kidd, an art teacher at Riverdale Collegiate Institute in Toronto, recalled meeting Thomson at Ard's store. He wrote that he found Thomson in a dark corner having his lunch of sausage, biscuits, and a bottle of pop. When he asked Thomson why he came all the way to South River to buy supplies, rather than going to one of many towns nearer to him, he answered simply, "Not by canoe." He told Kidd he liked to get his supplies in South River, where there was a veneer mill, and to meet up with the forest rangers who lived there.[17]

Oil on composite wood-pulp board, 21.6 x 26.8 cm
Thomson Family Collection

Snow in October

winter 1916–17

Thomson would have conceived of this canvas, with its interlocking network of snow and ice on the branches of trees, as an essay on one of the major themes for nationalist painters – Canada, Our Lady of the Snows. As in other paintings of the 1916–17 season, his formal touch has lightened up and become more delicate. The space of the picture is more open, too.

Thomson developed the painting from a number of sketches he had made of snow-covered trees, one of which has a pliant sapling extending almost the full vertical height in the foreground and a similar feeling of light (*Snow-Covered Trees*, National Gallery of Canada). Here, though, his real subject is the materiality of paint and its marriage with light. He laid the paint onto the canvas with a loaded brush, building up a rich encrustation laced with myriad colours.

In the process, the landscape was transformed and illuminated, with thick snow all over. Thomson enriched the pattern of the snow on the trees until it covered nearly half the canvas, like a puffy, lacy comforter. He painted the piles of snow on the ground in delicate shades of pink, blue, and cream. In the distance blocks of light appear among the snow-covered trees in rectangular shapes of orange and green.

The subject of snow knows no real national boundary, and Thomson here proved himself an able student of those who were taking up the investigation of colour and light. The adventurous exuberance of this painting, made two seasons before the artist's death the following summer, is inspirational.

Oil on canvas, 82.1 x 87.8 cm
National Gallery of Canada, Ottawa
Bequest of Dr. J.M. MacCallum, Toronto, 1944 (4722)

Maple Saplings, October

winter 1916–17

As in *Snow in October* (page 125), in this painting Thomson introduced a central motif that runs vertically through the picture and opens up the space. He indicated several young trees with slender trunks that curvaceously push their way upward in front of a flatly delineated background screen of woods and foliage. The centre sapling in particular, with its meandering branches, adds excitement and energy to the composition, as does the vivacious handling of the colour in large patches of orange, red, and dark purples or blacks. Thomson was careful to indicate the pale turquoise sky visible through the foliage – another device that contributes to the feeling of space in this richly and expressively painted work.

This painting has an interesting provenance. It was among the paintings remaining in the Studio Building after Thomson's death and went to his sister Elizabeth Harkness. It passed from her to her brother George Thomson, and around 1941 it was sold to the art dealer A.R. Laing of Laing Galleries, Toronto. His son G. Blair Laing owned it for four years before selling it in Montreal. The work passed through the hands of several private collectors and the Watson Art Gallery in Montreal before it returned to Blair Laing in 1973. In 1990 he sold it to Ken Thomson.

The effect of the work is remarkable. It draws much of its power from the way Thomson balanced lights and darks and his indication of subtle illumination in the heart of the forest. This colour feast is a work of great clarity and complexity that also makes poetic sense – a light-filled marvel of bravura handling.

Oil on canvas, 91.4 x 102.0 cm
Thomson Family Collection

The West Wind

winter 1916–17

MacDonald thought there was a fault in *The West Wind* – likely the way the tree trunk and rocks in the foreground are boldly blocked in, whereas the sky and water are more delicately brushed. He and Harris did not campaign for its acquisition by a major institution, but Jackson thought the Art Gallery of Toronto (now Art Gallery of Ontario) should have a large Thomson painting in its collection; so, with his friend Harold Tovell, Jackson persuaded the Canadian Club to donate it to the gallery in 1926.

The mood in the work feels elegiac, like the last days of autumn before the first snowfall. Thomson often used the theme of a tree by a lake in his paintings; this one has garnered near-universal admiration. Arthur Lismer saw this particular canvas as a symbol of the Canadian character – steadfast and resolute against adversity. Whatever his goal, Thomson attempted to convey here some of the breezy energy of the wind in Algonquin Park.

Many different locations have been suggested for the painting. Winnifred Trainor believed it was painted on Cedar Lake, and, most recently, Stan Verscay, a dedicated camper from Bowmanville, said Thomson painted it at Manitou Lake. Dr. MacCallum, however, recalled that Thomson painted his sketch for *The West Wind* while he, Thomson, and Lawren Harris were on a trip to Cauchon Lake.[18] If that is correct, in this major canvas Thomson may have wished to remind Harris in a painter's way of the time they spent together in Algonquin Park. Certainly, in shape and size, both *The West Wind* and *The Jack Pine* recall Harris's work of the period.

Oil on canvas, 120.7 x 137.9 cm
Art Gallery of Ontario, Toronto
Gift of the Canadian Club of Toronto, 1926 (784)

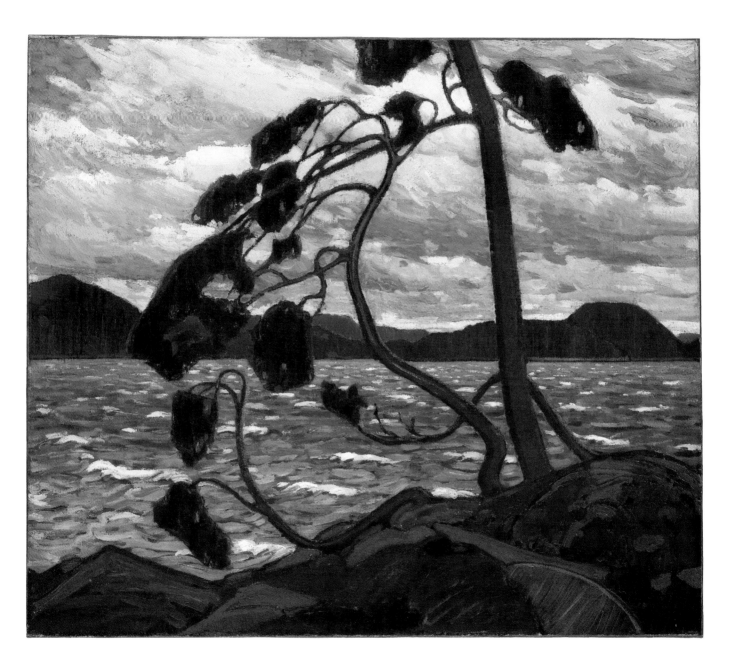

The Jack Pine

winter 1916–17

The Jack Pine is more finished and resolved than *The West Wind*, but the mood is different. Through the powerful image of this tree, Thomson was trying to give expressive form to his impression of Algonquin Park. His broad handling of paint in parallel bands and the almost square format are reminiscent of some of Harris's paintings of the period, but Thomson obviously relished a subject that was recognizably his own. The art historian Charles C. Hill has written that, in contrast to the breezy energy of *The West Wind*, *The Jack Pine* is a contemplative picture, though the two large canvases in no way form a contrasting pair.[19]

The Jack Pine helps to illuminate Thomson's importance to the later Group of Seven. He created formally direct and emotionally sympathetic images out of the landscape of the North – of a kind none of his peers seemed able to do. Up close the blocks of colour seem intended to jar, the brushwork almost too bold, but from a short distance away the image has a resolved graphic power. The undercoat of vermilion beneath the rocks, tree, and hills helps to give this painting its dramatic force. Certainly the image of the jack pine has become an instantly recognizable Canadian icon.

Eric Brown, the director of the National Gallery of Canada, described *The Jack Pine* as Thomson's best painting. In the spring of 1918 he bought it for the gallery, along with another major canvas, *Autumn's Garland*, and twenty-five sketches for $2,125 (there is no breakdown for individual items).

Oil on canvas, 127.9 x 139.8 cm
National Gallery of Canada, Ottawa
Purchase, 1918 (1519)

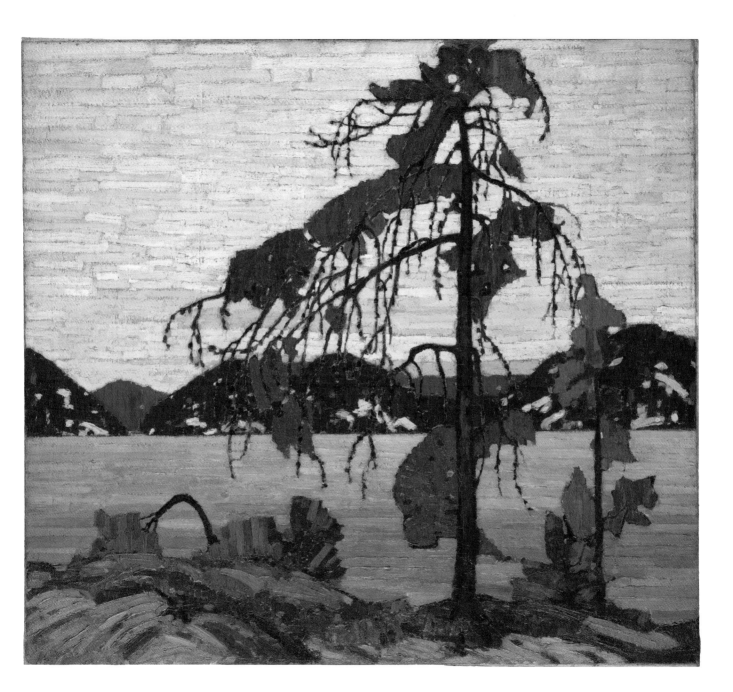

Early Spring, Canoe Lake

spring 1917

In 1917 Thomson arrived at Canoe Lake early in April, eager to paint the snow in the bush and the breakup of ice on the lakes. The receding snow and partially frozen lake in this sketch indicate that he painted it before April 21. We know from a letter he wrote to Dr. MacCallum that a thunderstorm that day washed away most of the snow, except for remnants in the swamps and in the bush on the north sides of the hills.

Thomson's handling of paint in this sketch reveals the speed with which he worked: trails of paint run between the marks he made with his brush. He also let the material work for him – the surface of the wooden board shows through the paint to give the sketch a sense of spontaneity and light. Thomson used many colours to paint the snow – pinks, greys, and creams. He created a sense of distance by using firm brushwork for the dark shapes of islands and hills, and lightly interwoven strokes of pink, green, and blue for the sky, which seems to undulate in repeating wavelike ripples. Throughout the work he used the expensive ultramarine blue to great effect, though it appears only sparingly. The energy of the work suggests Thomson's excitement about his experience of spring – this miraculous time of renewal, regeneration, and new growth.

Harris and MacDonald would surely have selected this work had it been in the Studio Building in 1918. However, it had already been acquired by Shannon and Annie Fraser, who managed Mowat Lodge, the tourist resort where Thomson often stayed at Canoe Lake. They sold the painting to their bookkeeper, George W. Chubb, who had met Thomson in the spring of 1915 and was interested in his paintings.

Oil on wood, 21.6 x 26.7 cm
Thomson Family Collection

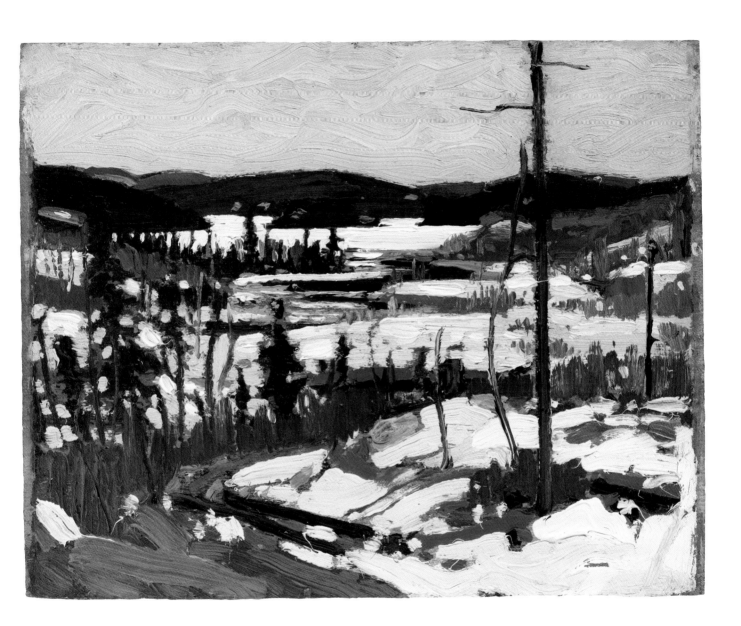

Open Water, Joe Creek

spring 1917

On the back, in pen, MacCallum wrote, "Open Water, Joe Creek," thus identifying where this work was painted. MacDonald also wrote in graphite on the verso, "Not for Sale – JM," because he and Harris wanted to reserve this sketch for one of their friends to purchase. They probably mentioned it to Barker Fairley, a professor at the University of Toronto who in the early 1920s became friendly with members of the Group of Seven at the Arts and Letters Club, because he later owned the work.

In 1917 Thomson arrived at Canoe Lake in Algonquin Park at the beginning of April. The local forest ranger Mark Robinson reported that Thomson painted a sketch every day that season, "showing the various stages of the advancing spring and summer."[20] In this sketch he cast a searching eye on the alterations in the landscape, richly detailing the changes made by the unfolding season – the gentle colour of the sky and the creamy whites, coral, olive green, and browns of the trees and saplings. The waters of the creek are just opening up – half of it is still covered with ice and the other half open, the flowing water distinguished in black.

Thomson painted this work before another sketch done the same season – *April in Algonquin Park* (Tom Thomson Art Gallery) – in which the waters are considerably more open and larger patches of land emerge from the snow. In these sketches Thomson let the wood panel show through the paint in some places to open up the space and create a lively quality to the whole. In his final spring of 1917 he seemed to have found a new breadth of vision and a real serenity in his work.

Oil on wood panel, 21.5 x 26.8 cm
Thomson Family Collection

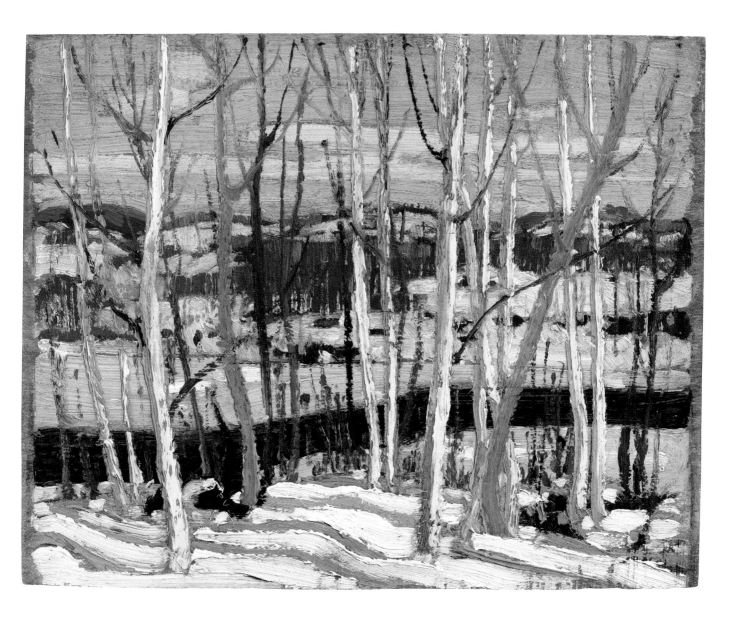

Early Spring

spring 1917

On the verso of this sketch Harris wrote, "Reserved L.S. Harris per R.A. Laidlaw." Laidlaw did not buy it, however, and it remained with Thomson's family. In 1974 Margaret Tweedale, Thomson's sister, gave it to the McMichael Canadian Art Collection.

The panel is a beautiful evocation of spring in Algonquin Park. "I have been here over three weeks and have done considerable work for that length of time," Thomson wrote to Tom Harkness, the husband of his sister Elizabeth.[21] He continued, "We still have a foot or two of snow on the north side of the hills yet but another week will see the end of it."

In this sketch Thomson painted the snow on the hills and the pockets of earth that had begun to appear around the trees. As before in his work, he used a cut-off view for the trees and the land, and, in the foreground, he included a shadow from a tree somewhere outside the picture, to make the viewer feel part of the work. The sketch reveals the cool light of the North and the burgeoning spring – two of the trees are painted green, a sign of growth.

Harris felt a special affinity for works by Thomson that not only were well composed but also used colour to reveal its maximum intensity. In this sketch he would have admired the well-defined slope that gives a feeling of depth and structure to the painting. Thomson's use of colour is also interesting: the blue in the shadows of the trees and the distant sky, the pinks and greens of the birches, and the patches of exposed panel, which give the sketch a vibrant informality.

Oil on wood panel, 21.1 x 26.7 cm
McMichael Canadian Art Collection, Kleinburg, Ontario
Gift of Margaret Thomson Tweedale, 1974 (1974.9.5)

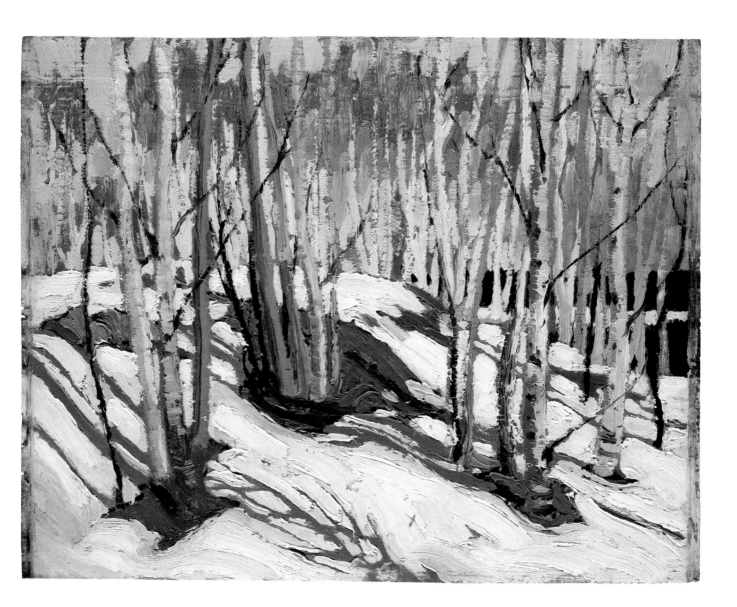

Path Behind Mowat Lodge

spring 1917

In the spring of 1917 Thomson stayed at Mowat Lodge on Canoe Lake in Algonquin Park at the same time that Toronto visitors Lieutenant R.L. Crombie and his wife, Daphne, were there. Thomson told Mrs. Crombie to look through his sketches and select any one she liked as a gift. She wisely chose this work.

The crispness and freshness of the sketch spell out Thomson's genuine maturity as an artist. The composition is powerful and the colours intriguing and effective. Here Thomson combined shadows of cerulean blue and green and a sky composed of light blue with dots of a different green. By now he could convey movement into depth with confidence, using the sloping curve of the path to help create a sense of passage into the woods. In a letter of April 15, 1969, to Dr. R.H. Hubbard of the National Gallery of Canada, Ottelyn Addison, who had written about Thomson and discussed this sketch with Daphne Crombie, said the sketch depicts a winter lumber road behind Mowat Lodge. Mrs. Crombie particularly admired the long shadows on the snow. When she noticed that the work was unsigned, she asked Thomson for his signature. He picked up a nail and drew it through the paint to incise his name.[22]

Oil on wood, 26.8 x 21.4 cm
Thomson Family Collection

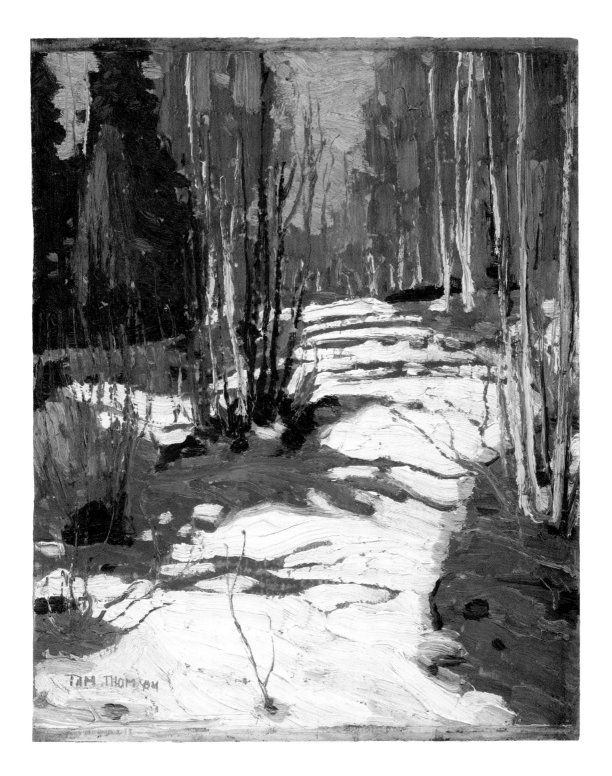

The Rapids

spring 1917

On the verso of this work Lawren Harris wrote, "Reserved Studio Bldg. L.S. Harris." A.Y. Jackson also admired this beautiful sketch and purchased it, though he had earlier written his name on the back of *Morning* (page 61). As he explained to his niece Dr. Naomi Jackson Groves, "I never could paint a river the way Thomson could."[23]

The sketch is suffused with a remarkable energy that gives us a plain-spoken but dazzling image of the season in Algonquin Park. The shapes in the river, landscape, and sky are irregularly descriptive, resembling calligraphy and creating free-flowing structures rather than imprisoned forms. Even the little lines Thomson used to indicate birch trees seem to leap up the hillside just as the waters leap over the rocks. The colours too have a brilliance and brio that recall what Harris said of Thomson – his "easy and deft yet inspired skill in applying paint which drew from the colour its maximum vitality." Amid the dark and muted colours Thomson used to indicate the hillside, trees, and water, the white of the snow comes as a surprise. The ultramarine blue, too, which Thomson applied only sparingly, enlivens the whole.

This sketch is one of the most beautiful works by Thomson still held in a private collection.

Oil on wood panel, 21.6 x 26.7 cm
Thomson Family Collection

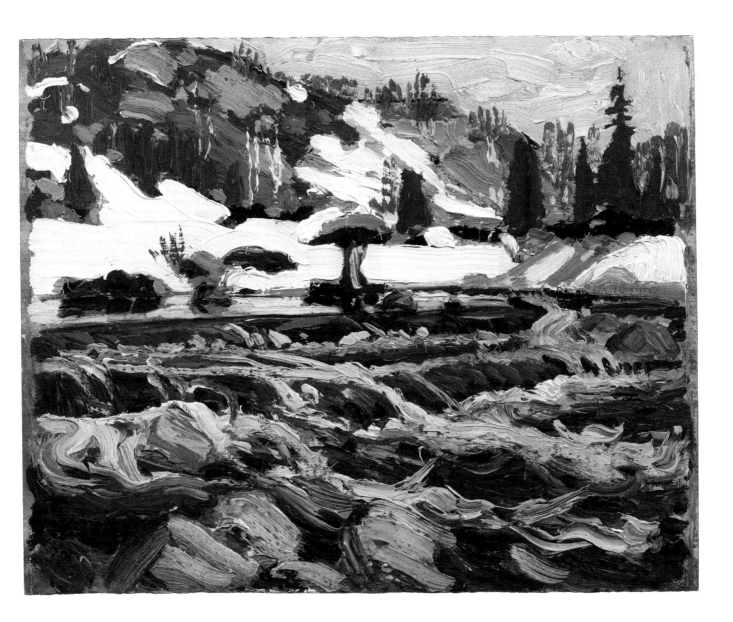

Spring Flood

spring 1917

After Tom Thomson died, his brother George went to Canoe Lake and brought Thomson's few possessions back to the family – as well as the sketches he had painted during the spring of 1917. Harris must have sought these sketches out because he marked the verso of this work and other paintings from that group in the same way as those he and MacDonald found in the Studio Building. On the back of this sketch he inscribed, "R.A.L. reserved Lawren Harris for R.L.," putting it aside specifically for his wealthy friend Robert Laidlaw to purchase. In 1966 Laidlaw gave it to the McMichael Canadian Art Collection.

This impressive sketch reminds us of what was lost to Canadian art when Thomson died – a brevity and expressiveness in approach that would take artists many years to find again. This work delivers a powerful impact, even though the painting has a lightness, almost a gaiety, of touch. The snow is receding in places to reveal the ground cover, painted in shades of green, brown, blue, and white; the trees are almost flying upward, like exclamation marks; the hills are covered with burgeoning vegetation in orange and gold and the occasional patch of distant snow; and the sky appears turquoise through the soaring cloud shapes in delicate peach, pink, lavender, and off-white. The result is a glorious panorama that, at the same time, is a tale of wonder.

Oil on wood, 21.2 x 26.8 cm
McMichael Canadian Art Collection, Kleinburg, Ontario
Gift of R.A. Laidlaw, Toronto (1966.15.23)

Spring

spring 1917

Harris wrote on the verso of this sketch, "Save for Lawren Harris." With these words he marked it as one within a special group he wished to reserve for himself, friends in the art community, or institutions he especially valued, such as the Art Gallery of Toronto (now Art Gallery of Ontario). In 1927 Harris donated three of his own Thomson sketches to the gallery (pages 77, 81, and 119), so he likely advised the gallery to purchase this one at the same time. To him these four pieces offered an understanding of Thomson's strongest work. This painting, through its extremely simple composition and its delicacy of colouring and handling of paint, extends the vision of Thomson's work as it was represented in the sketches Harris donated. In it, using a few deft strokes of the brush, Thomson caught a generalized view of landscape and the nuances in tonality of the spring sky at dawn.

"The weather has been fine and warm," Thomson wrote Dr. MacCallum on May 8, 1917, though on July 7, in another letter to MacCallum, he wrote that the weather "has been wet and cold all spring."[24] Whatever the conditions on the day he made this sketch, the mood in the painting is one of great serenity.

In *The Story of the Group of Seven*, Harris wrote: "Thomson knew the north country as none of us did, and he made us partners in his devotion to it. His last summer saw him produce his finest work. He was just moving into the full tide of his power when he was lost to us."[25] And that is why he felt honour-bound to help with Thomson's work: he loved him.

Oil on wood panel, 21.6 x 26.7 cm
Art Gallery of Ontario, Toronto
Gift from the Reuben and Kate Leonard Canadian Fund, 1927 (855)

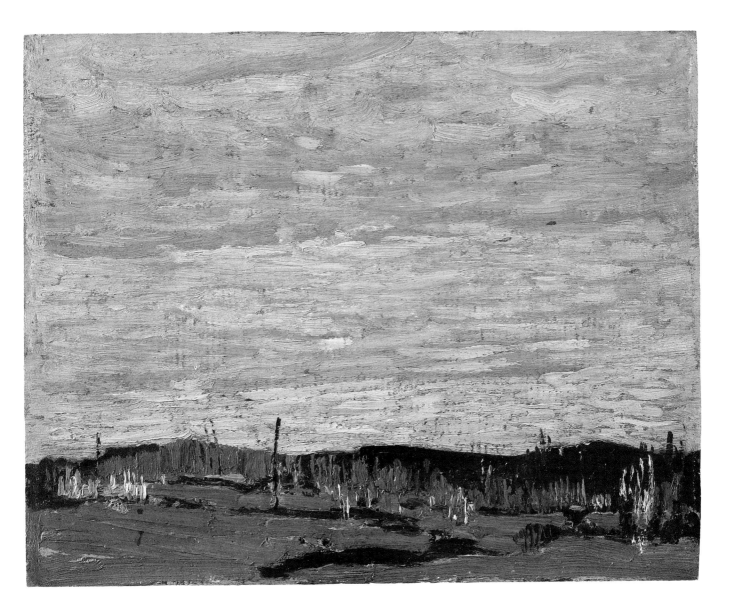

Notes

Notes to Creating a Legacy

1. Most notably, Eric Brown had bought the large canvas *Northern River* for the National Gallery of Canada, Ottawa, in 1915 and *Spring Ice* in 1916 (pages 35 and 91).

2. We know this from notes he made in a sketchbook. MacDonald sketchbook 1914–22, page dated October 22, 1917, 18906, National Gallery of Canada Archives, Ottawa.

3. A.Y. Jackson to J.E.H. MacDonald, August 4, 1917, McMichael Canadian Art Collection Archives, Kleinburg, ON.

4. MacDonald, "A Landmark of Canadian Art," *The Rebel* 2, no. 2 (November 1917): 45–50.

5. Harris, *The Story of the Group of Seven*, reproduced in Murray, *The Best of the Group of Seven*, 27.

6. Bess Harris and R.G.P. Colgrove, eds., *Lawren Harris* (Toronto: Macmillan of Canada, 1969), 43.

7. The painting was once owned by R.G.P. Colgrove, Toronto, who, along with Bess Harris, edited a book on Lawren Harris in 1969 (see note 6). The painting's present location is unknown.

8. The catalogue is in the McMichael Canadian Art Collection Archives, Kleinburg, ON.

9. The Jackson quote is from a letter A.Y. Jackson wrote to J.M. MacCallum, October 13, 1914, Dr. James M. MacCallum Papers, National Gallery of Canada Archives, Ottawa. The Varley quote is from a letter, F.H. Varley to James MacCallum, "Wednesday" [October 1914], MacCallum Papers, National Gallery of Canada Archives.

10. Thoreau MacDonald, appendix in *Tom Thomson: The Algonquin Years*, 87.

11. Jackson told this story to his niece. Dr. Naomi Jackson Groves, Ottawa, to Joan Murray, April 1971, Joan Murray Thomson files, private collection.

12. See Murray, *Flowers*.

13. Eric Brown, "The Function of an Art Gallery," *Ottawa Citizen*, November 13, 1914.

14. Eric Brown, "Re National Gallery," *Ottawa Citizen*, January 18, 1917.

15. "Speaker Advocates Subsidies to Art," *Ottawa Citizen*, October 31, 1917.

16. See Hill, "Tom Thomson, Painter," in Reid, *Tom Thomson*, 140, n. 168, where he refers to a letter from J.E.H. MacDonald to Eric Brown, October 14, 1921, MacCallum Collector's file, National Gallery of Canada Archives, Ottawa.

17. In 1920 the Art Gallery of Toronto had hosted a memorial exhibition for Tom Thomson but, because of a lack of funds, did not purchase any work.

18. Murray, *Tom Thomson: The Last Spring*, viii.

19. McMichael, *One Man's Obsession*, 407.

20. The works by Thomson owned by W.C. Laidlaw (1875–1962) mostly passed, late in his life or after his death, to his brother R.A. Laidlaw (1886–1976).

21. McMichael, *One Man's Obsession*, 197; and in conversation with the author.

22. Ken Thomson, in conversation with the author.

Notes to the Treasury of Paintings

1. A.Y. Jackson, foreword to *Catalogue of an Exhibition of Paintings By the Late Tom Thomson* (Montreal: Arts Club, 1919).

2. The catalogue is in the McMichael Canadian Art Collection Archives, Kleinburg, ON.

3. The letter is in the MacCallum Papers, National Gallery of Canada Archives, Ottawa.

4. There is much speculation that Winnifred Trainor was engaged to Thomson at the time of his death. She worked as a book-keeper and lived with her family in Huntsville, but they spent much of each summer at their cottage on Canoe Lake.

5. Letter from Thomson to Dr. James MacCallum, April 22, 1915, MacCallum Papers, National Gallery of Canada Archives, Ottawa.

6. Mark Robinson diary, entry for April 28, 1915, Trent University Archives, Peterborough, ON.

7. McMichael, *One Man's Obsession*, 399.

8. Harris, *The Story of the Group of Seven*, quoted in Murray, *The Best of the Group of Seven*, 28.

9. Housser, *A Canadian Art Movement*, 118.

10. The letter is in the McMichael Canadian Art Collection Archives, Kleinburg, ON. Brown was writing an article about the Algonquin Park School, as Thomson and his artist friends were sometimes called, for the international art magazine *The Studio*, and he had written to MacDonald for information. Obviously MacDonald had sent the letter on to Thomson to get input from him. See also page 110, *Petawawa Gorges*.

11. The letter is in the Edward P. Taylor Research Library and Archives, Art Gallery of Ontario, Toronto.

12. "Alex Edmison Interviews Mark Robinson," tape recording made at Canoe Lake, 1953, first carbon copy, October 1956, 5, quoted in Murray, *The Best of the Group of Seven*, 15.

13. Ernest Freure to Blodwen Davies, November 19, 1935, Blodwen Davies Papers, MG 30, D4 volume 1, Library and Archives Canada, Ottawa.

14. Edward Godin to Blodwen Davies, November 17, 1930, Blodwen Davies Papers, MG 30, D38 volume 11, Library and Archives Canada, Ottawa.

15. The letter is in the McMichael Canadian Art Collection Archives, Kleinburg, ON (see note 10).

16. Town and Silcox, *Tom Thomson*, 170.

17. The letter with this information from Kidd was written to Miss Etta Tolchard in November 1963, regarding a sketch by Thomson purchased in 1917 for Riverdale Collegiate.

18. The letter from Dr. MacCallum to Miss A.L. Beatty at the Art Gallery of Toronto, May 14, 1937, is in the Edward P. Taylor Research Library and Archives, Art Gallery of Ontario, Toronto.

19. Hill, "Tom Thomson, Painter," in Reid, *Tom Thomson*, 141.

20. Mark Robinson, interview by Alex Edmison, 1952, Algonquin Park, excerpt reproduced in Murray, *Tom Thomson: The Last Spring*, 94.

21. The letter is postmarked April 23, 1917. Tom Thomson Papers, MG 30, D284, Library and Archives Canada, Ottawa.

22. The letter is in the Curatorial Accession files, National Gallery of Canada, Ottawa.

23. Dr. Naomi Jackson Groves, Ottawa, to Joan Murray, April 1971, Joan Murray Thomson files, private collection.

24. MacCallum Papers, National Gallery of Canada Archives, Ottawa.

25. Harris, *The Story of the Group of Seven*, quoted in Murray, *The Best of the Group of Seven*, 28.

Selected Bibliography

148

Harris, Lawren. *The Story of the Group of Seven*. Toronto: Rous & Mann, 1964. Reproduced in Murray, *The Best of the Group of Seven* (Hurtig ed.), 26–31.

Hill, Charles C. "Tom Thomson, Painter." In Reid, *Tom Thomson*, 111–43.

Housser, F.B. *A Canadian Art Movement: The Story of the Group of Seven*. Toronto: Macmillan, 1926.

MacDonald, Thoreau. Appendix in *Tom Thomson: The Algonquin Years*, by Ottelyn Addison and Elizabeth Harwood, 84–87. Toronto: Ryerson Press, 1969. Reprint, Toronto: McGraw-Hill Ryerson, 1975; 1995 (anniv. ed.). Citations refer to the Ryerson Press edition.

McMichael, Robert. *One Man's Obsession*. Scarborough, ON: Prentice-Hall Canada, 1986.

Murray, Joan. *The Best of the Group of Seven*. Edmonton: Hurtig, 1984. Reprint, Toronto: McClelland & Stewart, 1993. Citations refer to the Hurtig edition.

———. *The Best of Tom Thomson*. Edmonton: Hurtig, 1986.

———. *The Birth of the Modern: Post-Impressionism in Canadian Art, c. 1900–1920*. Oshawa, ON: Robert McLaughlin Gallery, 2003.

———. *Canadian Art in the Twentieth Century*. Toronto: Dundurn, 1999.

———. "Chronology." In Reid, *Tom Thomson*, 307–17.

———. *Flowers: J.E.H. MacDonald, Tom Thomson and the Group of Seven*. Toronto: McArthur, 2002.

———. *Lawren Harris: An Introduction to His Life and Art*. Toronto: Firefly Books, 2003.

———. *McMichael Canadian Art Collection: One Hundred Masterworks*. Kleinburg, ON: McMichael Canadian Art Collection, 2006.

———. *Northern Lights: Masterpieces of Tom Thomson and the Group of Seven*. Toronto: Key Porter Books, 1994. Reprinted as *Masterpieces: Tom Thomson and the Group of Seven*. Toronto: Prospero Books, 2004.

———. *Tom Thomson: Design for a Canadian Hero*. Toronto: Dundurn, 1998.

———. *Tom Thomson: The Last Spring*. Toronto: Dundurn, 1994.

———. "Tom Thomson: Trailblazer and Guide." In *Canadian Art: The Thomson Collection at the Art Gallery of Ontario*, 104–17. Toronto: Skylet Publishing / Art Gallery of Ontario, 2008.

———. *Tom Thomson: Trees*. Toronto: McArthur, 1999.

———. "Tom Thomson's Letters." In Reid, *Tom Thomson*, 297–306.

Reid, Dennis, ed. *Tom Thomson*. Toronto: Art Gallery of Ontario; Ottawa: National Gallery of Canada; and Vancouver: Douglas & McIntyre, 2002.

Shields, Conal, ed. *Ken Thomson the Collector: The Thomson Collection at the Art Gallery of Ontario*. Toronto: Skylet Publishing / Art Gallery of Ontario, 2008.

Town, Harold, and David P. Silcox. *Tom Thomson: The Silence and the Storm*. Toronto: McClelland & Stewart, 1977.

Webster-Cook, Sandra, and Anne Ruggles. "Technical Studies on Thomson's Materials and Working Method." In Reid, *Tom Thomson*, 145–51.

Appendix

Tom Thomson's Best Paintings as Selected by the Group of Seven

Tom Thomson's artist friends who came together as the Group of Seven in 1920 regarded him as "one of us." They have left us a record of their favourite sketches and paintings through the pieces they owned themselves and by what they wrote about them, particularly the inscriptions they made on the backs of the works Thomson had left in the Studio Building in Toronto and on those they came across later.

The selections are listed here under the name of each artist and are divided by ownership and description. The paintings are given in alphabetical order by title. The works that are illustrated in this book are cross-referenced to the page where they appear. The others include the season and year in which they were likely painted as well as their present location.

Tom Thomson

Petawawa Gorges (p. 109) J.E.H. MacDonald wrote on the verso: "Tom considered this sketch his best & intended [making?]…it a large picture."

Lawren Harris

Harris owned the following works by Thomson:
Autumn Birches (p. 119)
Black Spruce and Maple (p. 77)
Burnt Land (p. 37) Harris acquired the painting from Thomson, c. 1915.
A Rapid (p. 81) Harris probably acquired this painting from Thomson in 1915.

Harris wrote "first class," "1st class," or "Save for Lawren Harris" on the verso of the following works by Thomson:
Autumn, Algonquin Park (p. 33)
Autumn, Algonquin Park (fall 1916), location unknown
Autumn, Canoe Lake (fall 1914), private collection
Birches and Cedars (Fall) (p. 85)

Blueberry Bushes, October (p. 121) "1st class" is written but then crossed out.
Burnt Land (p. 47)
Early Spring in Cauchon Lake (p. 99)
Early Winter Frost (winter 1914), private collection
Petawawa Gorges (p. 109)
Sand Hill (p. 79)
Spring (p. 145)
Tamarack Swamp (p. 75)
Tamaracks (fall 1915), location unknown
Wild Cherries, Spring (p. 43)
Wild Cherry Trees in Blossom (p. 45)
Wild Geese: Sketch for "Chill November" (p. 115)
Wildflowers (p. 53)

Harris wrote on the verso of these works "reserved Studio Bldg. Lawren Harris," "(L.S. Harris)," "Lawren Harris / Studio Bldg.," "Reserved / L.S. Harris / per R.A. Laidlaw," "reserved / Lawren Harris / Laidlaw," or "reserved Bob Laidlaw per [or for] Lawren Harris." Harris also sometimes wrote the names of people other than Laidlaw, likely possible purchasers, such as "reserved Dr. Mabie per L.S. Harris" on the verso of *Landscape, Algonquin Park*. On one work, *Ragged Pine*, "reserved…[for?] Laidlaw" is crossed out.
Burnt Land at Sunset (p. 49)
Dappled Thicket (fall 1916), McMichael Canadian Art Collection, Kleinburg (1974.9.6)
Early Spring (spring 1917), Art Gallery of Ontario, Toronto (849)
Early Spring (p. 137)
Landscape, Algonquin Park (spring 1916), Thomson Collection, Art Gallery of Ontario, Toronto (964)
A Northern Lake (summer 1914), Thomson Collection, Art Gallery of Ontario, Toronto (69220)
Ragged Pine (fall 1916), location unknown
The Rapids (p. 141)
Spring Flood (p. 143)

J.E.H. MacDonald

MacDonald owned the following works by Thomson:
Marguerites, Wood Lilies and Vetch (p. 51)
Sunset, Canoe Lake (fall 1915), location unknown

J.E.H. MacDonald and/or Lawren Harris wrote "Not for Sale,"
"Not for Sale reserved Studio Building," "reserved SB – not for
Sale," or "Not for Sale J.E.H. MacDonald / reserved" on the
verso of the following works by Thomson:
Approaching Snowstorm (p. 69)
Aura Lee Lake (spring 1916), McMichael Canadian Art Collection,
 Kleinburg (1970.2)
Autumn, Algonquin Park (p. 113)
Autumn Foliage (fall or winter 1915), Art Gallery of Ontario,
 Toronto (852)
Birch and Spruce, Smoke Lake (spring 1915), private collection
Black Spruce and Maple (p. 77)
Crib and Rapids (fall 1915), private collection
The Dead Pine (p. 105)
Early Winter North (fall 1916), private collection
Evening, Fall (fall 1916), National Gallery of Canada, Ottawa (40983)
First Snow, Canoe Lake (p. 89) On the verso is written
 "Not For … [label torn]."
Ice in Spring (spring 1916), National Gallery of Canada,
 Ottawa (4576)
Ice in Spring (spring 1916), location unknown
Lightning, Canoe Lake (p. 59)
Marguerites, Wood Lilies and Vetch (p. 51)
Morning (p. 61)
Northern Landscape (p. 73)
Northern Landscape (fall 1916), private collection
Open Water, Joe Creek (p. 135)
Petawawa Gorges (p. 111)
Ragged Lake (p. 67)
Ragged Oaks (fall 1916), private collection
A Rapid (p. 81)
Red and Gold (fall 1915), private collection
Rock-Burnt Country (fall 1915), Montreal Museum of Fine
 Arts (985). On the verso "not for sale" is crossed out.
Spring, Algonquin Park (p. 95)
Spruce and Maple (fall 1916), National Gallery of Canada,
 Ottawa (4647)
Sun in the Bush (p. 103)
Water Flowers (p. 55)
Winter Morning (p. 41)

A.Y. Jackson

Jackson owned the following works by Thomson:
Lake, Shore and Sky (spring 1913), National Gallery of Canada,
 Ottawa (4565)
Nocturne (spring 1915), McMichael Canadian Art Collection,
 Kleinburg (1966.8.1)
The Rapids (p. 141)

Jackson marked the following work "AYJ; SB" [Studio Building]:
Morning (p. 61)

Jackson may have marked the following work with "AYJ":
Lumber Dam (summer 1915), National Gallery of Canada,
 Ottawa (6946)

Franklin Carmichael

Carmichael owned the following works by Thomson:
Hoar Frost (spring 1914), McMichael Canadian Art Collection,
 Kleinburg (1968.25.21). Thomson gave this sketch to
 Carmichael and his wife on the occasion of their wedding.
 Jackson wrote on the verso: "This is one of the finest
 Tom Thomsons I have ever seen."
Moonlight (fall 1914), Thomson Collection, Art Gallery of
 Ontario, Toronto (69192)

Frank H. Johnston

Johnston owned the following work by Thomson:
Clouds and Sky (fall 1913), private collection

Arthur Lismer

Lismer owned the following work by Thomson:
Spring Break-up (spring 1916), private collection

F.H. Varley

Varley owned the following work by Thomson:
Northern Lake (spring 1913), location unknown

Index

Page numbers of illustrations are shown in *italic* type.